IMAGES
of America

OAHU'S
NARROW-GAUGE
NAVY RAIL

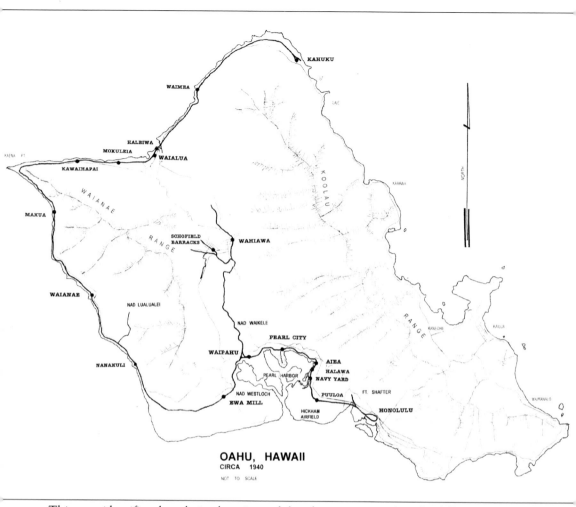

OAHU, HAWAII
CIRCA 1940
NOT TO SCALE

This map identifies the relative locations of the places mentioned in the following pages and shows the route of the Oahu Railway and Land Company, which connected all the military establishments on Oahu. (Stanley Kumura.)

On the Cover: Navy Yard Locomotive No. 6 (H.K. Porter Inc. construction No. 5635, built March 1915) is pictured testing the concrete-imbedded track on the First Street pier extension on February 8, 1928. (14th Naval District Photograph Collection, courtesy of the National Park Service, World War II Valor in the Pacific National Monument.)

IMAGES
of America

OAHU'S
NARROW-GAUGE
NAVY RAIL

Jeff Livingston

ARCADIA
PUBLISHING

Published by Arcadia Publishing
Charleston, South Carolina

Printed in the United States of America

Library of Congress Control Number: 2014935111

For all general information, please contact Arcadia Publishing:
Telephone 843-853-2070
Fax 843-853-0044
E-mail sales@arcadiapublishing.com
For customer service and orders:
Toll-Free 1-888-313-2665

Visit us on the Internet at www.arcadiapublishing.com

*For the members and supporters of the Hawaiian Railway
Society, past, present, and future, for keeping the rich
history of railroads and railroading in Hawaii alive.*

CONTENTS

Acknowledgments 6

Introduction 7

1. Building a Shipyard: 1908–1920 9

2. Expansion: 1921–1940 47

3. World War II: 1941–1945 79

4. The Postwar Period and the End: 1946–1970 107

About the Organization 127

ACKNOWLEDGMENTS

As with most endeavors of this nature, the author is only the final step in a process involving many people that results in a snapshot of the topic covered. Some information has to be left out because of space constraints, and there is still much to learn. My good friend and mentor Robert "Bob" Paoa, historian emeritus of the Hawaiian Railway Society, has supported this project since I began research in 1990. John Bennett, Coast Defense Study Group, taught me how to do proper research and documentation. Equipment rosters compiled by Allen Copeland and Robert Lehmuth were instrumental in identifying locomotives and locomotive cranes. Without the help of Scott Pawlowski and Stan Melman, staff members at the National Park Service, World War II Valor in the Pacific National Monument, images from the 14th Naval District Photograph Collection would have been unobtainable. Many others contributed to this work, including Mike Raymond (research and photographs), Stanley Kumura (research and mapmaking), Randy Hees (research), and John Goldie (location of vintage photographs). Most of the Word War II photographs contained in this book were donated to the Hawaiian Railway Society by Bill Blewett and the late Victor Norton, both of whom deserve special recognition and thanks. Images noted as (NPS) appear courtesy of the National Park Service, World War II Valor in the Pacific National Monument, 14th Naval District Collection, and those noted as (HRS) are from the Hawaiian Railway Society Collection.

INTRODUCTION

The first shore-based presence of the US Navy in the "Sandwich Islands," as Hawaii was then known, was in 1860 when a small, 1,000-ton coaling station was established on leased land in Honolulu Harbor. Little used because of the Navy's policy requiring warships to operate under sail power as much as possible, the coaling station was of no actual or strategic value. The real military importance of Hawaii as a mid-Pacific way station was not recognized until 1898, during and immediately after the Spanish-American War, as the United States was attempting to transport troops and supplies to the new outposts in the Philippines and Guam. Following annexation of Hawaii by the United States that same year, plans were drawn up to increase the capacity of the coaling station to 20,000 tons and acquire additional land in Honolulu Harbor for naval purposes. Two naval wharves were to be constructed, and a survey was conducted of Pearl Harbor for potential future use. Naval Station Honolulu was officially established November 17, 1899, and was redesignated Naval Station Hawaii on February 2, 1900. A 1901 appropriations act allowed for the expansion of the naval station and a survey of Pearl Harbor, including land acquisition. By 1908, the naval station in Honolulu had grown to become an 85-acre naval reservation with multiple wharves, piers, enlarged coaling facilities, a pier crane, a machine shop, a smithy, a foundry, a water system, a wireless station, and housing. The Honolulu Harbor entrance had been dredged and the channel enlarged to allow the entry of larger ships, which benefited both the Navy and the civilian commercial interests of Honolulu. Other than the acquisition of 693.58 acres of land, which includes the current navy yard, Kuahua Island, and a portion of Ford's Island, little else was accomplished at Pearl Harbor. The initial dredging of the coral reef blocking the Pearl Harbor channel was completed in 1905. By 1907, encroachment by the US Army and other government agencies upon the grounds of the Naval Reservation in Honolulu caused such a restriction in operations that if adequate services to the fleet were to be provided, a move to Pearl Harbor would be necessary. An appropriations act dated May 13, 1908, established Naval Station Pearl Harbor and provided an initial $3 million for its development.

The centerpiece of the new Naval Station Pearl Harbor was the dry dock, which was planned to be largest yet built for the Navy. Construction began in 1909, and three-foot narrow-gauge railroad equipment in the form of one locomotive and some dump cars was acquired by the Navy for construction use. This was the beginning of the Navy's railroad operations on Oahu. Other than the dry dock, little other construction activity took place at Pearl Harbor until 1910, when the first shops and storehouses were begun. In addition to the dry dock and repair shops, a naval magazine was established on Kuahua Island in 1911. Kuahua Island is within Pearl Harbor, and a railroad causeway was later constructed between it and the naval station/shipyard. The building of a massive 100,000-ton coaling plant was authorized in 1912; it included the only standard-gauge railroad component ever built on Oahu. A naval hospital was begun in 1911, and a high-power radio station in 1914. Construction of the submarine base commenced in 1918. In parallel with all this facilities construction, infrastructure construction was also in progress, including water

and fuel oil reservoirs and distribution systems. The growth slowed in the 1920s and 1930s but continued, with the most significant change occurring with the establishment of Naval Magazine Lualualei and Naval Ammunition Depot West Loch, both rail served, in 1933. Construction activity again increased in the late 1930s as tensions mounted in the Pacific region. This increased construction activity included two additional dry docks and a six-million-barrel underground fuel facility located at Red Hill. A 24-inch-gauge underground railroad and conveyor system removed the tailings from the Red Hill project, which were used at Pearl Harbor to fill the area between Kuahua Island and the naval station.

Following the December 7, 1941, attack on Pearl Harbor, the first response involved salvage and repair operations. This was soon followed by massive construction projects at all Navy and Marine Corps bases, during which the Navy's railroad capability was severely tested. Among the many projects were the establishment of another rail-served ammunition facility at Waikele and the expansion of Marine Corps Air Station Ewa and Naval Air Station Barbers Point. The Navy's railroad capability was woefully inadequate at the beginning of World War II and was greatly expanded, first by the acquisition of used equipment and later by the incorporation of new equipment to meet the increasing needs of the war effort. This expansion included not only equipment but also the establishment of the District Rail Transportation Coordinator to control movement and use of all Navy-owned rail equipment, including that leased to the Oahu Railway and Land Company.

With the conclusion of the war in 1945, unlike at the beginning, the Navy had an excess of rail equipment, and all the steam locomotives were soon taken out of service and scrapped, as were most of the older, used freight cars received from the mainland. When the Oahu Railway and Land Company abandoned its main line on December 31, 1947, the rail connection was about to be broken between Pearl Harbor, Lualualei, West Loch, and Waikele. The Navy took an option on that track and maintained operations until 1954, when heavy rains washed out the connection near Waikele. Although repaired, the Waikele ammunition facility railroad was soon abandoned, and the rails were removed between Pearl Harbor and West Loch, leaving only Lualualei and West Loch with an active rail connection of about 12 miles in length. The last ammunition train made its way between Lualualei and West Loch in 1968, although rail operations continued internally at both facilities until 1972, when Navy railroad operations ceased after 63 years of service.

There are few remnants of the Navy's railroad today. The huge coaling plant has been reduced to a crumbling wharf, and only a few feet remain of the concrete barrier wall that once contained the thousands of tons of coal. The roundhouse (Building 58, built in 1942) is now used for heavy-machinery repair, with both standard-gauge and narrow-gauge track still in place. Track can still be seen in the pavement throughout the shipyard and in a number of the shop buildings, including some of dual-gauge construction. Only the mining railroad in the lower tunnel of the Red Hill fuel facility remains active. It is known locally as the "Howling Owl," and residents claim they can hear it rumbling deep underground.

One

BUILDING A SHIPYARD
1908–1920

The land surrounding Pearl Harbor is mostly ancient coral covered with a thin layer of soil and scrub growth. In some places, notably at the mouth of the Pearl River, marshes had formed. Construction in 1908 meant a need for manpower, horsepower, and steam power. While the construction of Pearl Harbor's dry dock, shops, and storage facilities were done under contract by civilian construction firms, the Navy itself built the infrastructure, including roads, fuel reservoirs, electrical distribution system, water and sewer systems, and the first piers. The infrastructure construction extended to Naval Magazine Kuahua, its causeway linking Kuahua Island to the Naval Station, and the submarine base. Temporary Navy construction railroads crisscrossed Pearl Harbor. The first Navy three-foot narrow-gauge equipment, a locomotive, arrived in 1909 along with a number of dump cars of unknown origin. The year 1911 saw the first permanent railroad construction. Two 15-ton locomotive cranes arrived in 1913, and a second locomotive arrived in 1914; all were narrow gauge. This equipment, along with one more narrow-gauge locomotive received in 1915 and a few flatcars and boxcars with additional locomotive cranes, formed the backbone of the Navy's construction railroad. The standard-gauge locomotives, locomotive cranes, and 20-yard dump cars that were ordered for the coaling plant and received around 1915, and the compressed-air locomotive used at Naval Magazine Kuahua received in 1914, were not used for general construction.

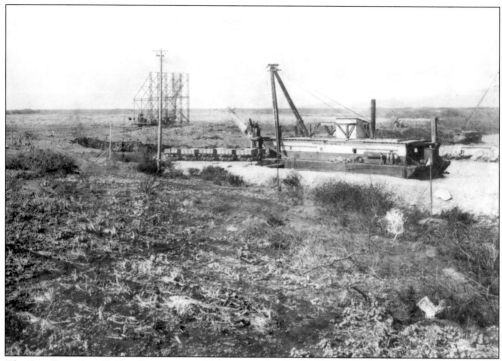

The San Francisco Bridge Company and Hawaiian Dredging Company were awarded the contract to build the Pearl Harbor dry dock in December 1908. This 1909 photograph is believed to be of the initial dredging operations for that project. A string of contractor dump cars is already on hand to move the spoil. (NPS.)

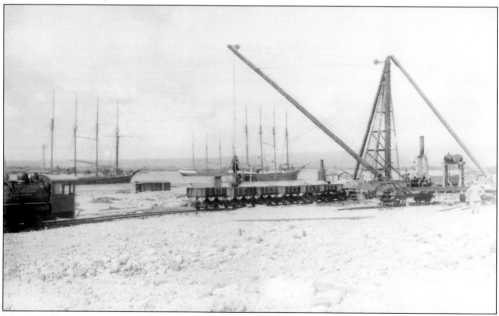

Navy Yard Locomotive No. 1 (H.K. Porter Inc. construction No. 4389, built August 1909) is working on the temporary construction tracks at Pearl Harbor around 1910. It would be the navy yard's only locomotive until 1914. The dump cars are likely owned by Hawaiian Dredging. (NPS.)

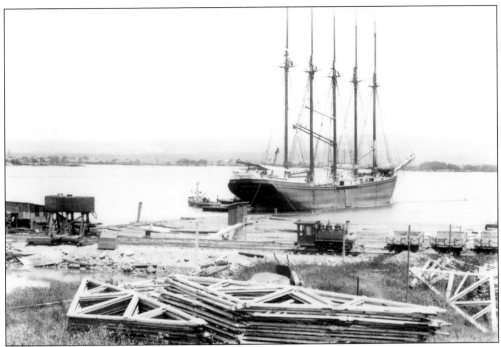

Wooden sailing ships were still the order of the day in 1910 for cargo shipments to Hawaii. This locomotive is unidentified but is believed to belong to Hawaiian Dredging, one of the multiple contractors building the shipyard. (NPS.)

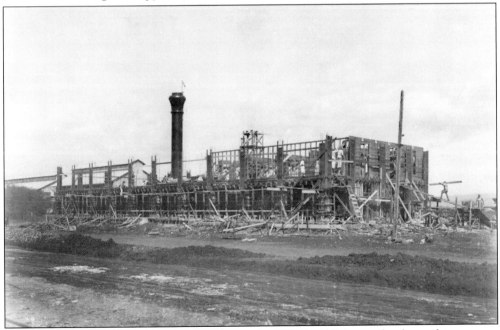

Construction of the shipyard was well underway by 1912. In addition to the shops, this concrete administration building was planned for the Navy staff who had yet to move from Honolulu. This building is still in use today, but the brick stack of the powerhouse, seen in the background, is now encased in concrete. (NPS.)

At the site of the new coaling plant, this photograph illustrates the original shoreline around Pearl Harbor, which also included ancient fishponds and marsh. Only a thin layer of soil covered the hard coral. (NPS.)

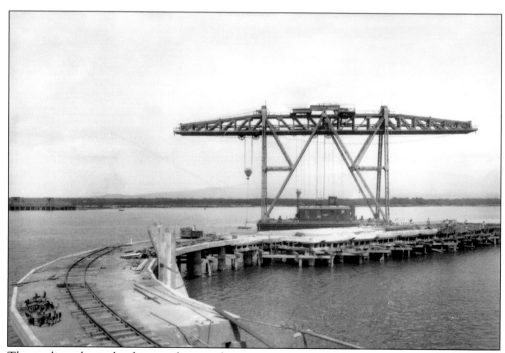

The coaling-plant wharf is seen here under construction, including temporary railroad tracks. The 150-ton Navy floating crane "Hulett" moored to the wharf would play a major role in Pearl Harbor's construction. (NPS.)

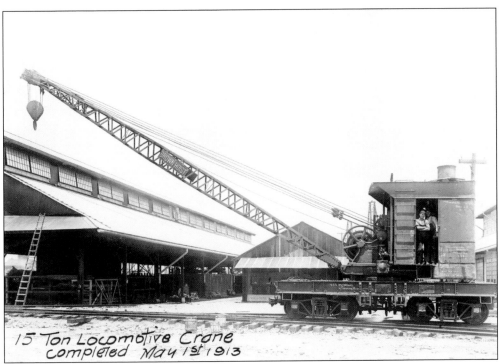

15 Ton Locomotive Crane
completed May 1st 1913

Two 15-ton Brownhoist locomotive cranes arrived at Pearl Harbor in 1913 to augment the existing equipment being used in the creation of the infrastructure needed to support the dry dock, shops, and storehouses then under construction. Streets, sewers, water and fuel supplies, and power were all required, making the cranes essential. (NPS.)

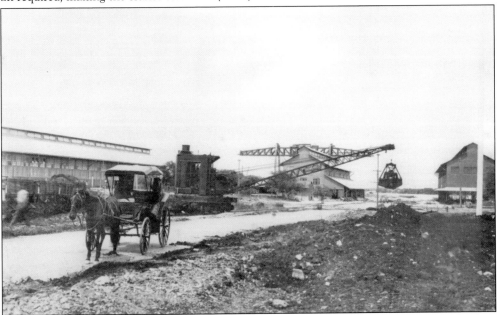

The cranes were quickly put to work. The one shown here is engaged in grading and loading the dump cars to the left. Material removed from one point in the yard was used as fill along the shoreline in other parts. (NPS.)

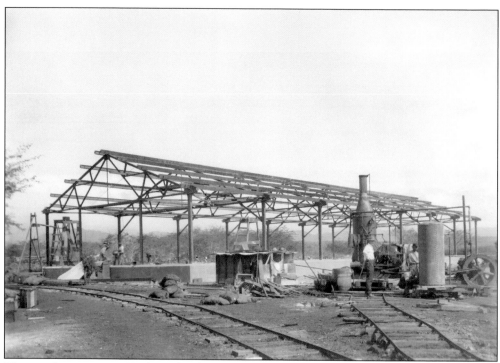

The naval magazine on Kuahua Island included a self-contained railroad system to move powder and shells to the wharf where ships would arm. Although a construction railroad was built, no motive power was available on the island. To build Magazine No. 1 (above) and the engine house (below), construction material was loaded on railcars that were moved by hand. (Both, NPS.)

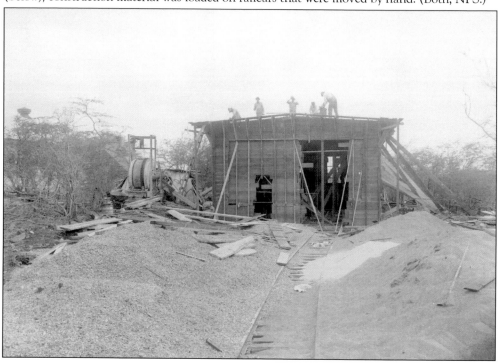

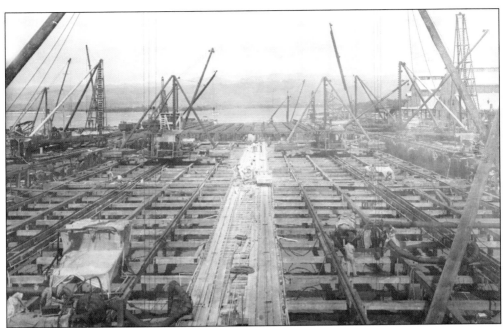

Construction of the initial shipyard buildings, support systems, and dry dock were nearing completion when the above photograph was taken on February 3, 1913. Two weeks later, on February 17, the dry dock suffered a catastrophe when hydrostatic pressure caused the concrete floor to heave up, resulting in the complete loss of all work accomplished since 1909 (below). Fortunately, no lives were lost, nor were the contractor's or shipyard's railroads affected. (Both, NPS.)

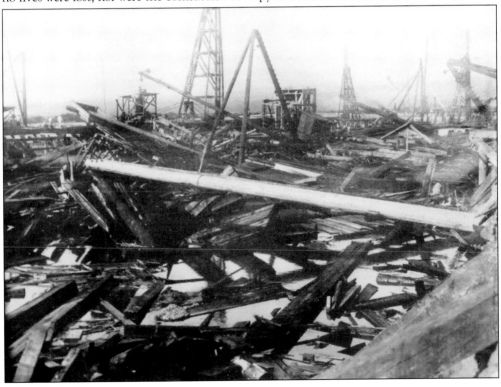

The naval magazine at Kuahua received a locomotive in 1914. A Class B-P compressed-air locomotive (H.K. Porter construction No. 5571, built August 1914) is shown in the new engine house along with its air compressor. The relatively unstable black-powder munitions of the day demanded the use of a compressed-air locomotive. A number of flatcars were also received, all equipped with link and pin couplers. (Both, NPS.)

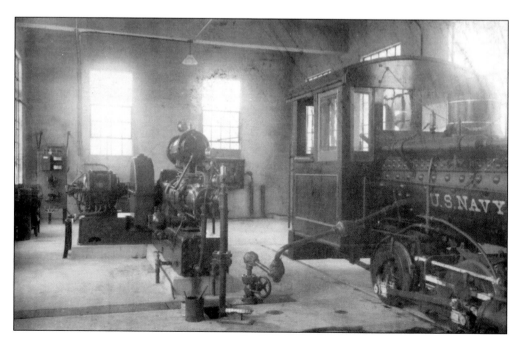

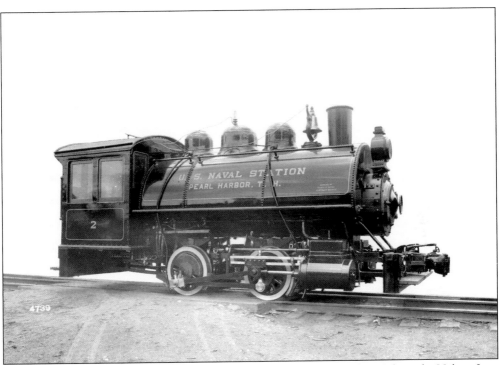

The second shipyard locomotive for Pearl Harbor was ordered in April 1913 from the Vulcan Iron Works. Navy Yard Locomotive No. 2, construction No. 2195, was built August 1914 and arrived in October the same year. (Hagley Museum and Library.)

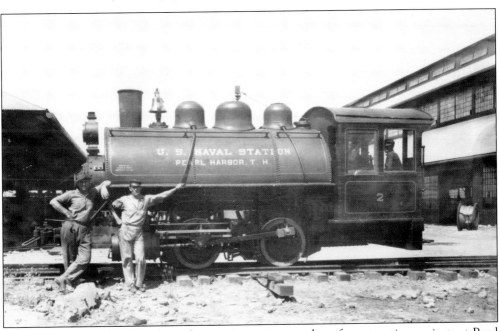

No. 2 was put straight to work on the ever-increasing number of construction projects at Pearl Harbor, which now included a marine barracks, naval and marine officer's quarters, gymnasium, and an elevated 200,000-ton coaling plant. (NPS.)

The year 1913 also saw an order to the Seattle Car & Foundry for five 30-ton flatcars. Navy Yard Nos. 1, 2, and 3 are shown in this builder's photograph loaded "knocked down," or disassembled, as was to become usual for shipments to Hawaii. These are the first documented freight car orders for Pearl Harbor. (John Lewis.)

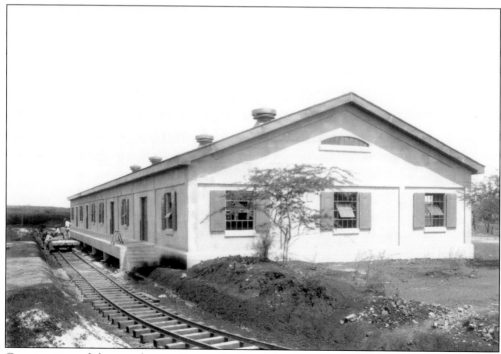

Construction of the naval magazine on Kuahua Island continued. The flatcar alongside the fixed ammunition house is believed to be one of the original link-and-pin coupler cars for the magazine. (NPS.)

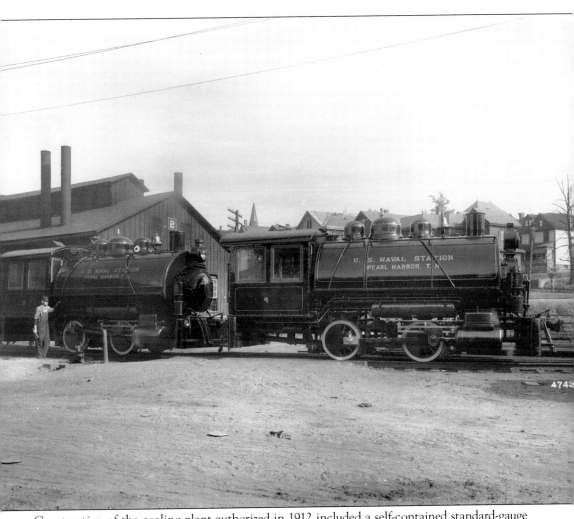

Construction of the coaling plant authorized in 1912 included a self-contained standard-gauge railroad, the only standard-gauge system to be built on Oahu. The coaling plant equipment arrived in Pearl Harbor well before completion of the plant itself. It is believed that the standard-gauge equipment was used in the construction of the coaling plant. Three standard-gauge locomotives were ordered from the Vulcan Iron Works to become Navy Yard Nos. 3, 4, and 5. This late 1913 Vulcan Iron Works builder's photograph shows Nos. 4 and 5. (Hagley Museum and Library.)

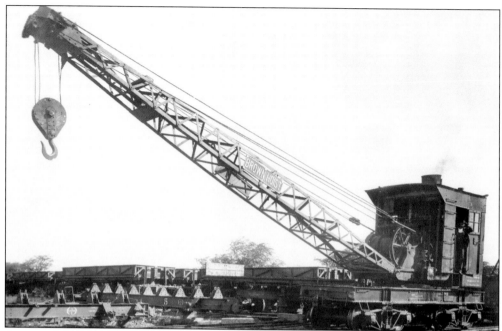

A contract for eight standard-gauge coaling plant locomotive cranes was placed in 1913. Two were to go to the Puget Sound Naval Shipyard, and six to Pearl Harbor. Only three standard-gauge cranes were actually received at Pearl Harbor. These 15-ton Brown Hoisting Machinery Company products were equipped with grab buckets and track clamps for operation on the elevated tracks of the plant. Three new 15-ton narrow-gauge cranes also appeared at Pearl Harbor at this time, believed to be the result of a modification to the standard-gauge crane contract, although no documentation has been located. (NPS.)

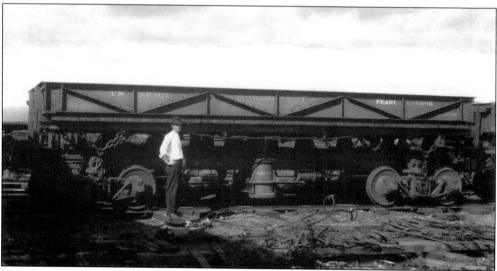

The railroad equipment of the coaling plant was completed with 15 air-operated dump cars, each with 20 cubic yards capacity. Built by the Wm. J. Oliver Manufacturing Company, they were used to move coal both to and from the piles below the elevated tracks of the plant. Although the locomotives were lettered "US Naval Station Pearl Harbor T.H.," these dump cars were lettered "US Naval Coaling Plant Pearl Harbor." (NPS.)

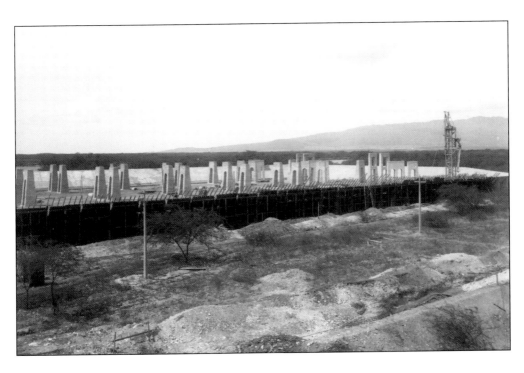

Although the concrete foundations are in place, the steel supports for the elevated tracks of the coaling plant have yet to be installed in the above photograph. As the steel structure necessary to support the locomotives, cranes, and dump cars was erected, it is believed the cranes provided assistance. (Both, NPS.)

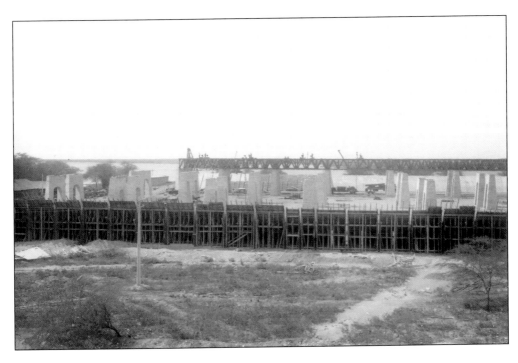

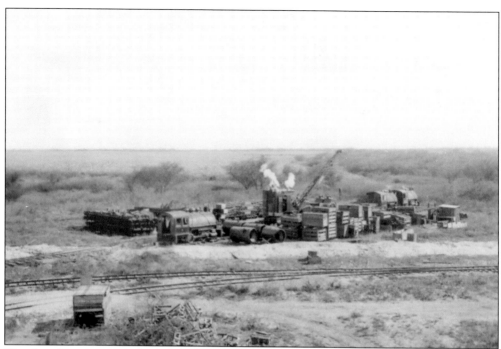

The three locomotives and one of the cranes for the plant sit in the sun on a loop of track waiting for a call to duty. Limited to the coaling plant because of their gauge, they were not useful to the overall development of the shipyard. The coaling plant did have a locomotive shed early on that stood adjacent to the steep ramp just visible to the right leading to the elevated tracks. (Both, NPS.)

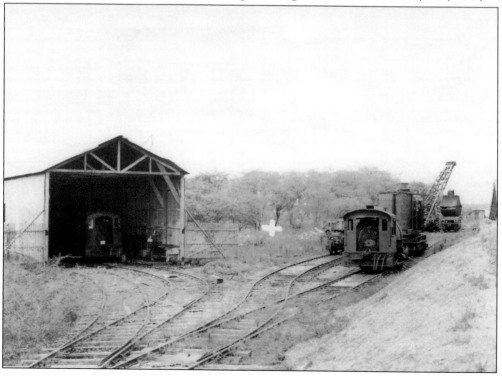

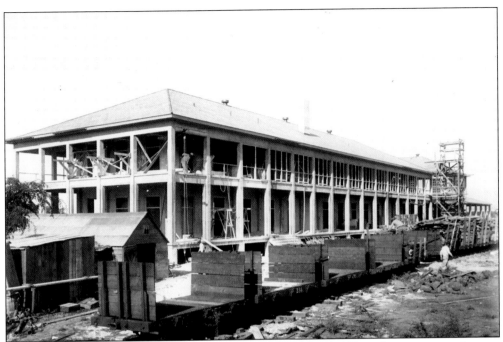

Construction of a Naval Hospital began at Pearl Harbor in 1915. Although not connected to any part of the shipyard's rail system, the contractors building the hospital made use of plantation-type equipment to aid in construction. (NPS.)

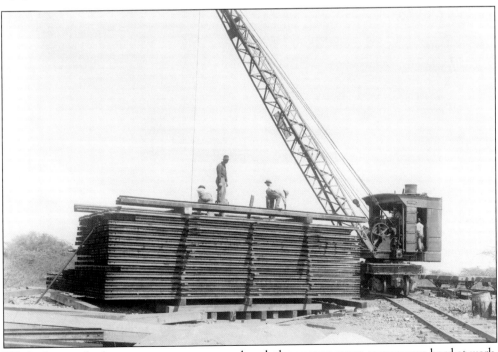

While the standard gauge cranes were unemployed, the narrow gauge cranes were hard at work. The one shown here is engaged in load testing one of the foundation points of a 600-foot antenna for the Pearl Harbor High Powered Radio Station. (NPS.)

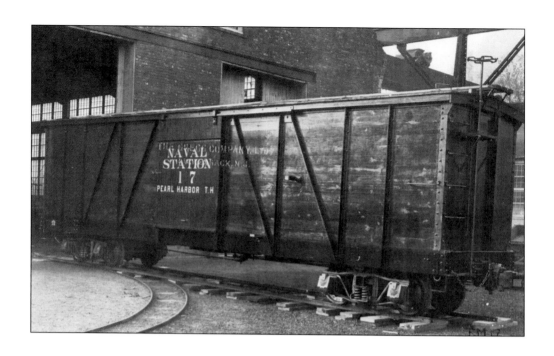

Additional rolling stock arrived at Pearl Harbor. Three boxcars and eleven flatcars of all steel-frame construction were received from the Gregg Company Limited in 1915. These builder's photographs show the cars at the Gregg shops in Hackensack, New Jersey, prior to their shipment to Pearl Harbor. (Both, R.T. Gregg.)

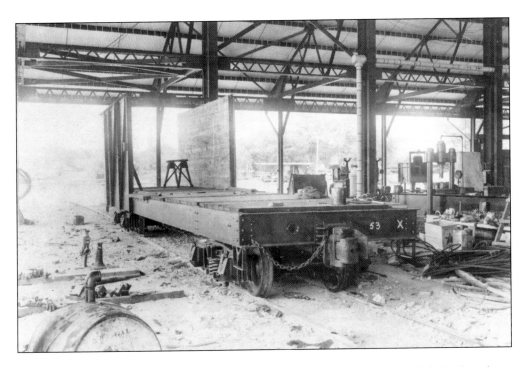

Shipping to Hawaii was then and is now expensive. Rolling stock that could be broken down into component parts was shipped disassembled to save space and cost. Although fully assembled in the Gregg shops, the boxcars were disassembled and shipped in pieces. Here, they are being reassembled at Pearl Harbor prior to use. Note that the same boxcar is pictured both in New Jersey and Hawaii. (Both, NPS.)

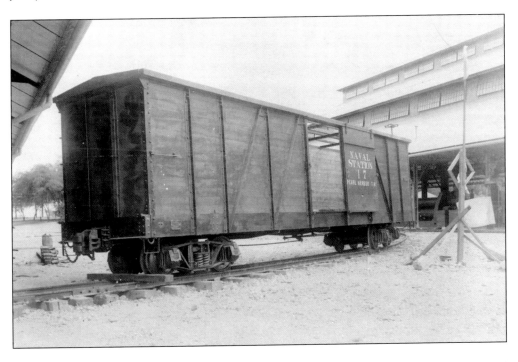

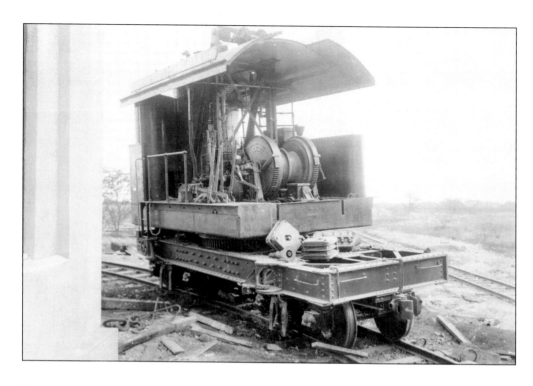

Two more narrow-gauge cranes were added to the shipyard's roster in 1915. These 10-ton American Locomotive Cranes, Navy Yard Nos. 9 and 10, were also shipped disassembled and rebuilt at the shipyard. (Both, NPS.)

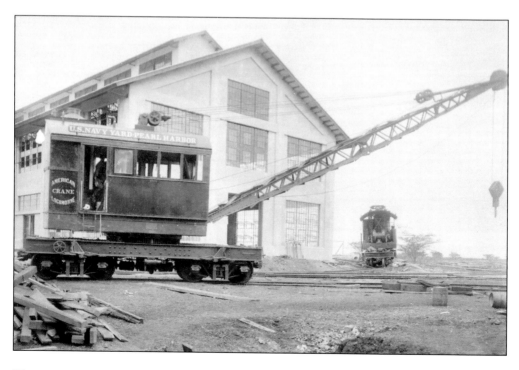

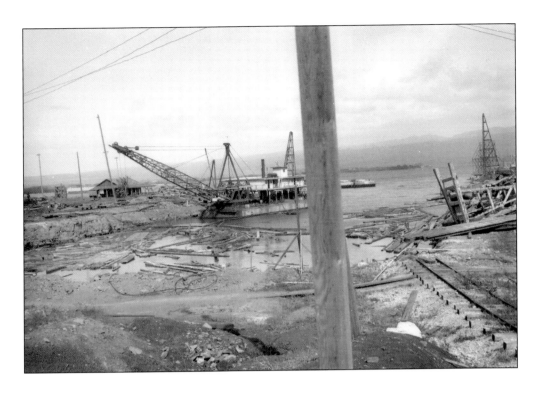

Work on the dry dock began again in 1915 for the first time since 1913. This followed an extensive investigation and reengineering to prevent another collapse. A Hawaiian Dredging gondola is seen at the work site, and contractor's rails extend to the water's edge as construction resumes. (Both, NPS.)

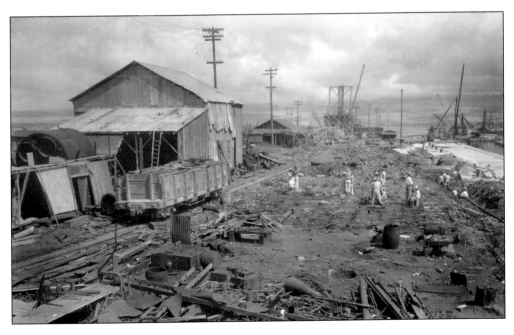

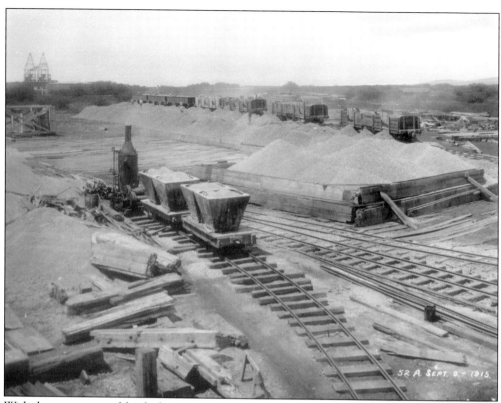

With the resumption of dry dock construction, both the contractor's plant and labor force expanded significantly. Above is a portion of the Hawaiian Dredging sand supply for the concrete plant with a mix of Hawaiian Dredging and Oahu Railway and Land Company equipment; below is an Oahu Railway and Land Company labor train on its way from Watertown, the Hawaiian Dredging base of operations just outside the shipyard proper, to Honolulu. (Both, NPS.)

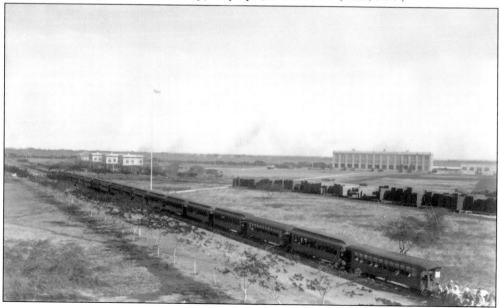

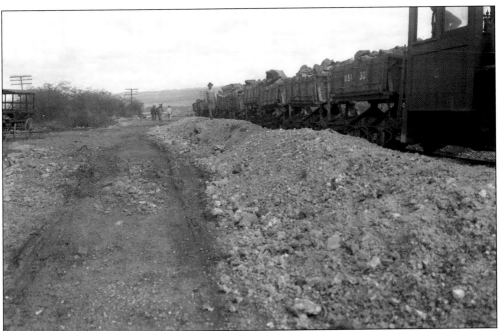

In 1915, the H.K. Porter Company supplied an additional navy yard locomotive. No. 6, another 0-4-0, construction No. 5635, was built in March of that year. Barely visible here in front of dump car USN 301, No. 6 is working its way to Kuahua with fill. (NPS.)

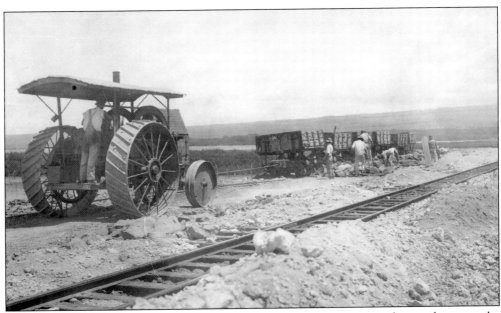

With only three narrow-gauge locomotives available, steam tractors were often used to move the dump cars once they were delivered to a job site. Here, a tractor has a cable attached to move the cars. (NPS.)

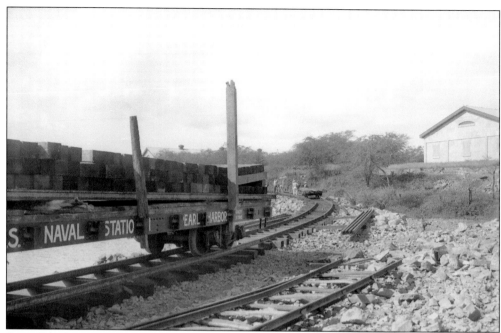

One of the larger fill projects was a causeway to connect the naval magazine on Kuahua Island to Pearl Harbor. The permanent track is nearing completion over the causeway, and the industrial track used to build the causeway is being removed. (NPS.)

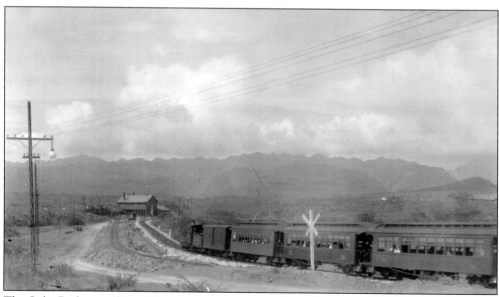

The Oahu Railway and Land Company's main line ran through portions of the shipyard's property. Here, a regularly scheduled passenger train heading to Aiea is running adjacent to the shipyard's track to Kuahua. (NPS.)

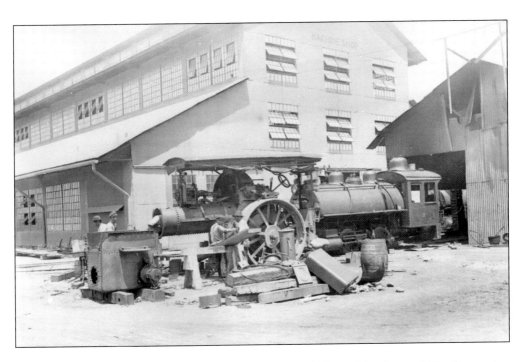

Railroad shop facilities were rudimentary at best in the early days of the shipyard. The first engine shed served all steam-powered equipment, not just the railroad. The climate made this mostly open-air facility possible. A proper repair facility was many years in the future. (Both, NPS.)

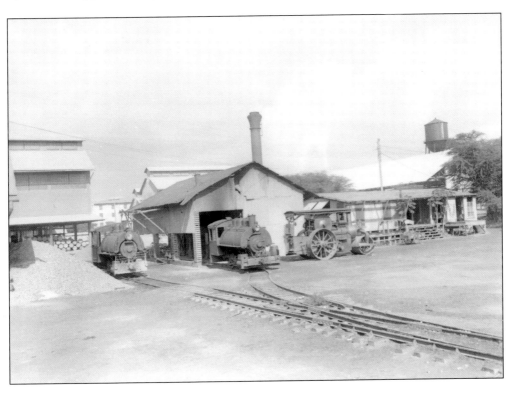

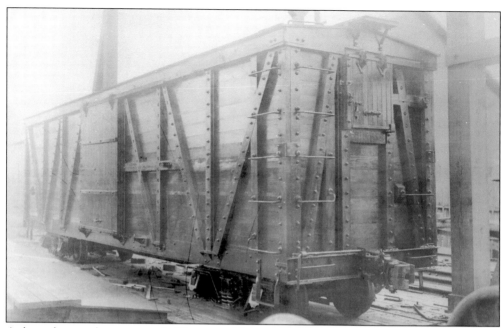

At least three and as many as six 20-ton steel-framed, wood outside braced boxcars were built for the Navy by the Seattle Car & Foundry in 1917. The original drawing accompanying this builder's photograph is marked "Pearl Harbor," although the car is not yet lettered. Note the roof assembly on the ground in the above photograph and the split coupler knuckle allowing the use of both automatic and link-and-pin couplers in the photograph below. (Both, John Lewis.)

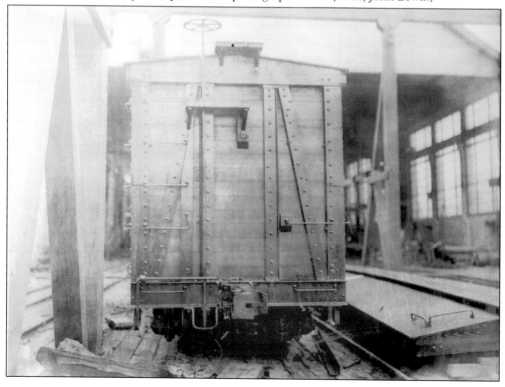

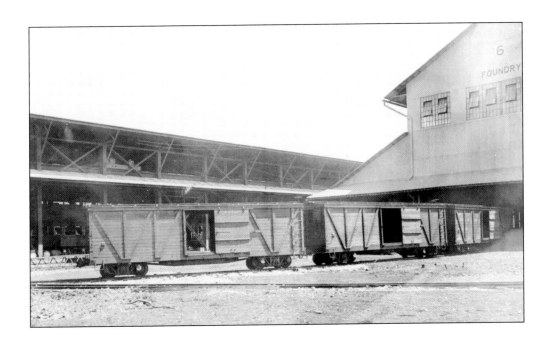

The Seattle Car & Foundry boxcars are being reassembled at the shipyard in the above photograph. The boxcars were assigned to the naval magazine on Kuahua Island, as shown by the lettering on the side sills in the 1918 image below. These cars were equipped with hand brakes only. (Both, NPS.)

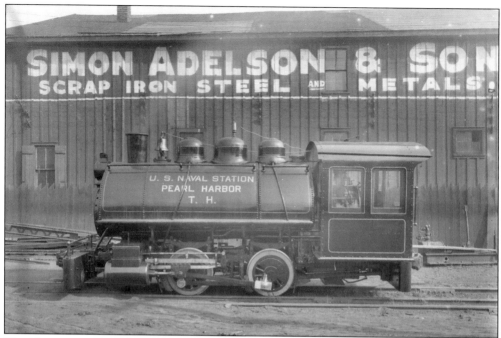

The Navy again turned to the Vulcan Iron Works in 1918 for Navy Yard Locomotive No. 8, construction No. 2822, shown here in a builder's photograph without a shipyard number. To date, no information has been located on any navy yard locomotive carrying the number 7, which seems to have been skipped. (Hagley Museum and Library.)

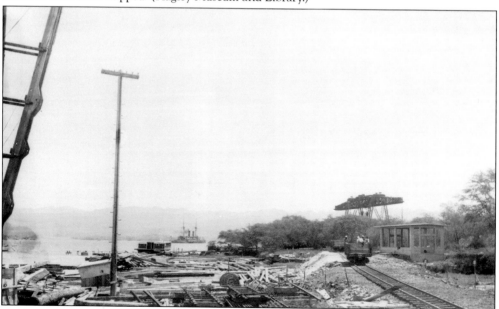

As the dry dock neared completion, additional projects were undertaken at Pearl Harbor. Shown here in 1918 is the beginning of the 10-10 wharf, designed to accommodate two rows of 10 destroyers, adjacent to the dry dock. The ship in the background is the Imperial Japanese cruiser *Tokiwa*, which protected Pearl Harbor while the bulk of the US fleet was in the Atlantic during World War I. (NPS.)

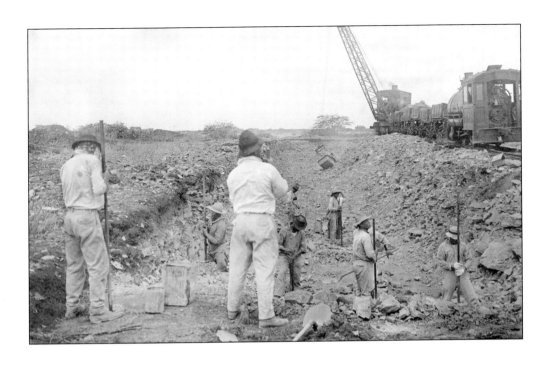

In addition to the coaling plant, a number of above-ground fuel oil storage tanks had been constructed at Pearl Harbor. Construction of a massive underground fuel oil reservoir was begun in 1917, with the shipyard's railroad playing a major part. Fill from this project was used to further increase the size of the shipyard and naval station, especially in the Merry Point and submarine base areas. (Both, NPS.)

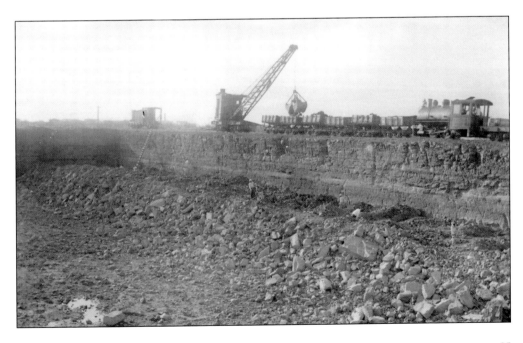

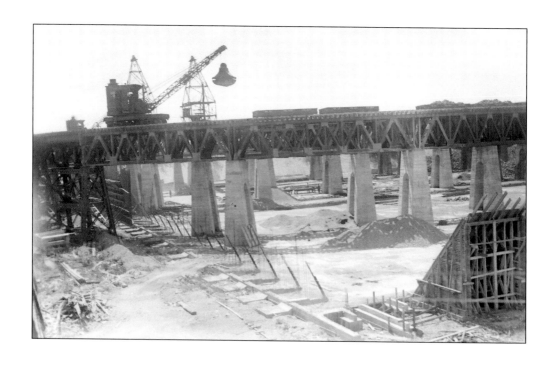

By 1918, the coaling plant was finally ready for use. The steel work was in place, and the retaining walls were nearing completion. Once the retaining walls were finished and coal stockpiled, seawater flooded the enclosure to reduce dust, preserve the coal, and contain any potential fire. (Both, NPS.)

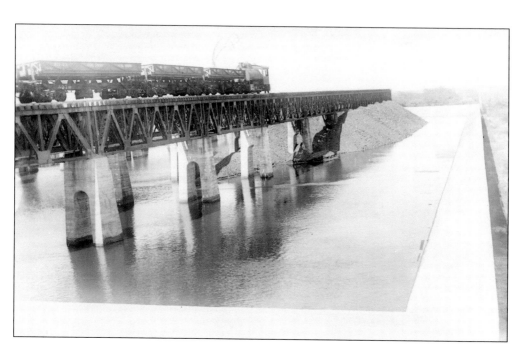

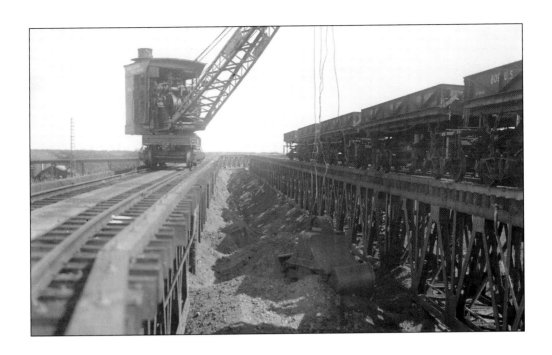

Operation of the coaling plant required moving coal from the stockpile into the dump cars by crane and moving the cars to the chutes for loading onto ships or barges. Below, a barge is being loaded for transshipment to a ship at anchor. (Both, NPS.)

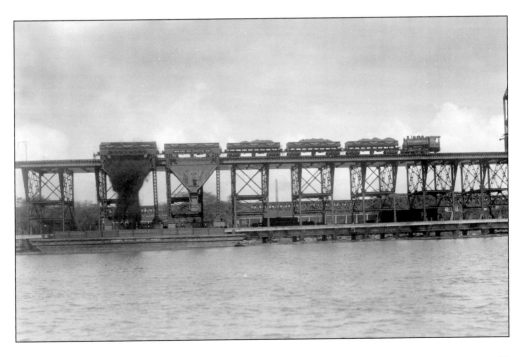

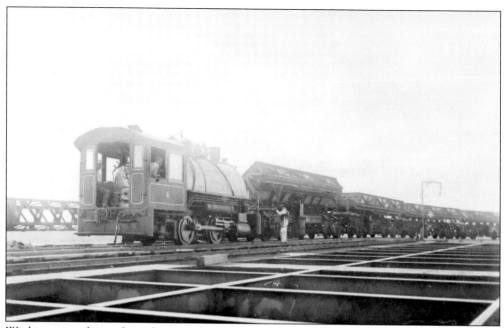

Working atop the coaling plant was hazardous and required some degree of nerve. Cars were dumped by air but were operated manually from a narrow catwalk high above the ground and water. (NPS.)

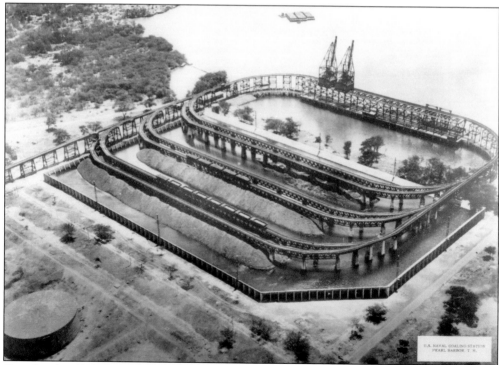

Completed in 1919, the coaling plant's usefulness was limited as most of the world's navies converted their warships' fuel from coal to oil. The coaling plant was to serve for many more years, however, providing coal for Navy and Army transports and civilian vessels. (NPS.)

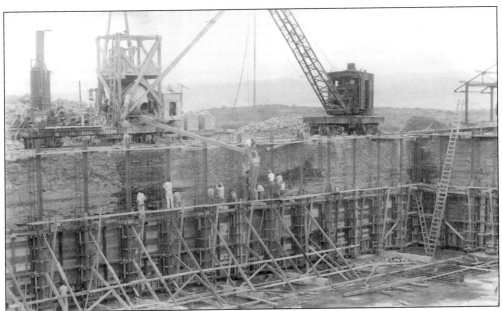

With the excavation of the fuel oil reservoir completed, concrete walls lining the excavation were poured. A concrete mixer was mounted on a flatcar for mobility, and dual parallel tracks were installed along the excavation. Concrete was placed by a series of chutes supported by the mixer with assistance by a locomotive crane, which also moved the mixer when required. (NPS.)

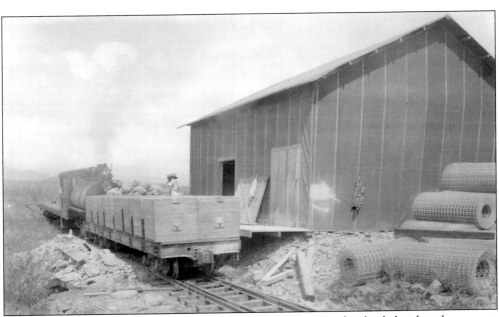

Concrete for the mixer was provided by batch boxes. Each box was first loaded with rock aggregate and then with bags of cement, as shown in this photograph. Each flatcar carried 14 batch boxes of this early ready mix. (NPS.)

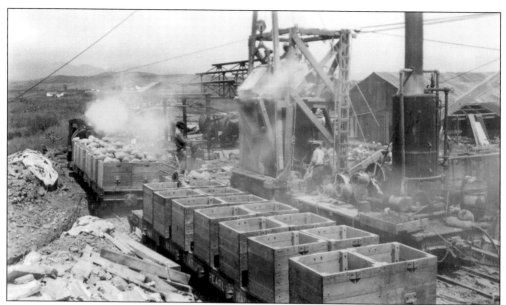

Batch boxes were delivered to the mixer on the parallel track. The mixer was rotated up, and the batch boxes dumped into the mixer by a self-contained lifting/tilting arm. When finished, the mixer rotated down to discharge into the chute and into the wall forms. (NPS.)

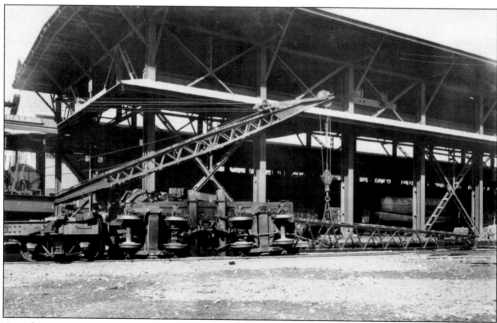

Accidents were uncommon but did happen. What caused this locomotive crane to tip over is unknown, but it was assuredly quickly righted and returned to service. The safety record of the shipyard is uncertain, but few serious injuries or deaths were reported in the local newspapers. (NPS.)

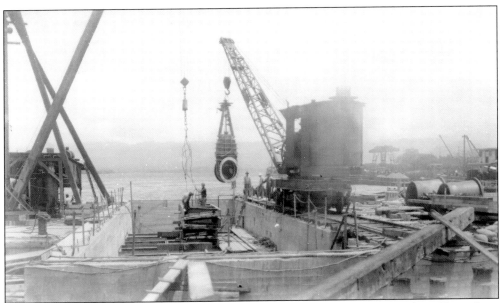

One of the standard-gauge locomotive cranes found work far from the coaling plant. Shown here on very isolated track, the crane is installing one of the 48-inch gate valves into the dry dock pump house. (NPS.)

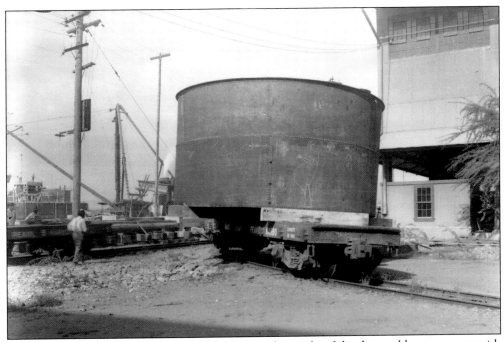

When it came to moving large and heavy objects, the trucks of the day could not compete with the railroad. Here, a section of a lubricating oil tank is being moved from the boiler shop to the coaling plant. (NPS.)

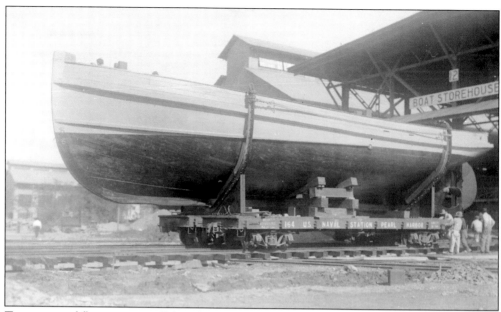

Two navy yard flatcars on parallel tracks were used to move the hull of Tug 90 from the boat shop to a waiting barge. Both the flatcars and the hull were loaded onto the barge, and then the hull was placed in the water by a floating crane. (NPS.)

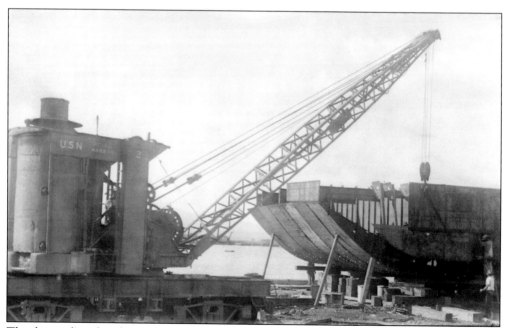

The shipyard's railroad cranes were not confined to construction of the shipyard only. Here, one of the cranes assists in the fabrication of a coal barge. (NPS.)

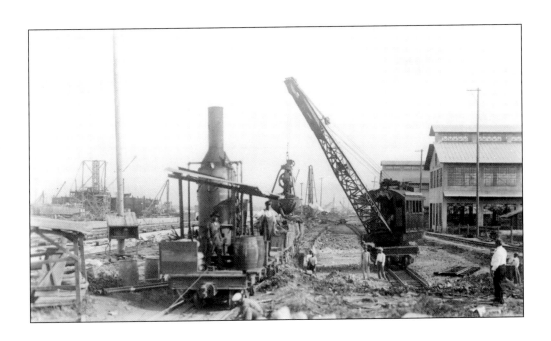

With the dry dock nearing completion, the grading of First Street parallel to the dry dock became a priority for the grand opening. Here is the First Street grading as seen in its final stages. Note the donkey engine mounted on the flatcar used as a cable locomotive. (Both, NPS.)

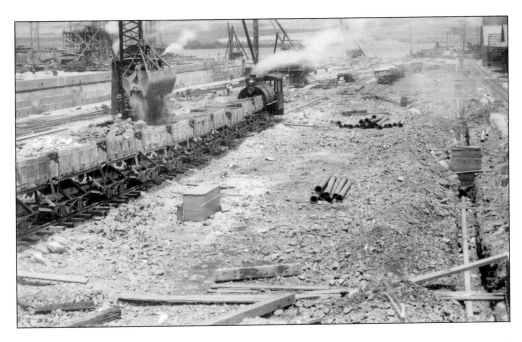

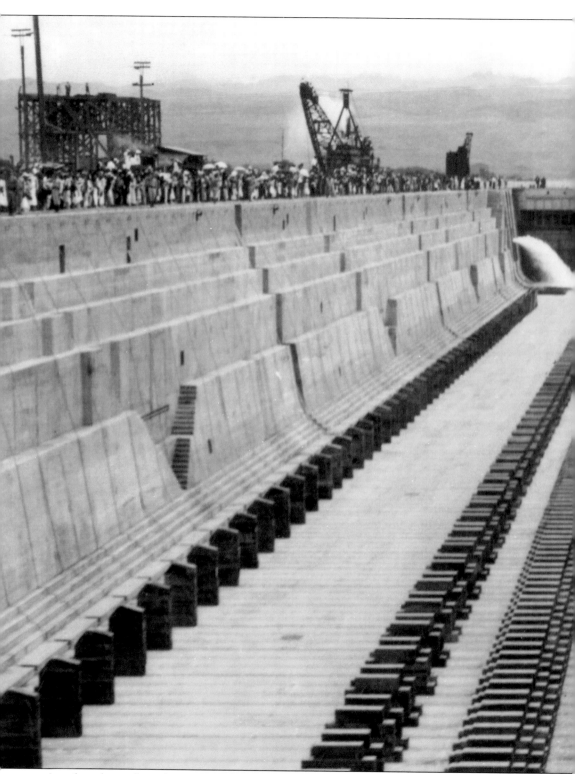

A gathered crowd watches as water begins flooding the dry dock—the Navy's largest and most

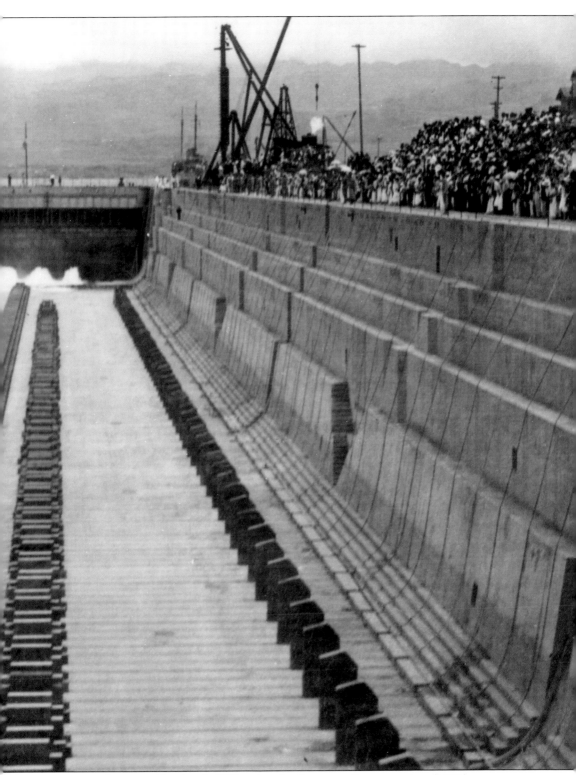

expensive to date—on October 1, 1919, a decade after start of construction. (NPS.)

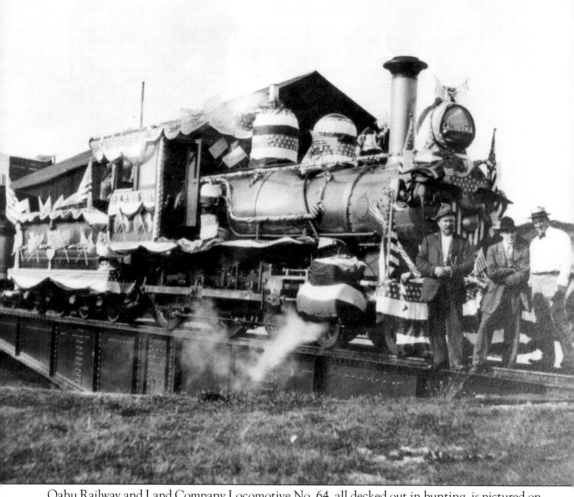

Oahu Railway and Land Company Locomotive No. 64, all decked out in bunting, is pictured on the turntable in Honolulu before pulling the "special" to the opening ceremonies for the Pearl Harbor dry dock. (NPS.)

Two

EXPANSION
1921–1940

The shipyard continued to grow through the 1920s, albeit at a slower pace. Improvements continued to be made to the submarine base, and wells were drilled in Aiea to provide a secure source of water for the Navy complex. Fill from dredging operations and excavation of fuel and water reservoirs was used along the shoreline to increase the available land and provide backfill for new wharfs and piers. The naval magazine on Kuahua Island, which was fast becoming a peninsula, was deemed too small for the Navy's increasing requirements and posed a potential hazard being in such close proximity to the repair facilities. A new naval magazine was established in the valley at Lualualei, an ammunition depot was located at West Loch, and new railroad equipment was ordered for both. Moves between Lualualei, West Loch, and Pearl Harbor were conducted over the mainline of the Oahu Railway and Land Company (OR&L) by OR&L locomotives and crews. In 1938, the shipyard contained 14.5 miles of narrow-gauge track, 2.5 miles of standard-gauge track, and eight locomotives, but only 23 freight cars of various types. Four of these cars carried the Wheeler bilge-cleaning system. These numbers do not include the three locomotives, seven flatcars, and six boxcars at Lualualei and West Loch. The Navy assumed any additional freight equipment could be provided by the OR&L. Two former US Army steam locomotives were transferred to the navy yard around 1939, and the first diesel mechanical locomotive—the first new locomotive since 1918—was delivered in 1940. With another war in Europe and increasing tensions in the Pacific, the Navy again reviewed its preparedness and found itself lacking. Contracts were awarded for the construction of two new dry docks, a second marine railway, and increased ship-repair facilities, including new piers and wharfs. The Navy's railroad continued to play an important part in this construction, supplemented by trucks and crawler cranes. The old railroad at Kuahua continued to serve as the magazines and other buildings became warehouses and offices for the Navy Supply System.

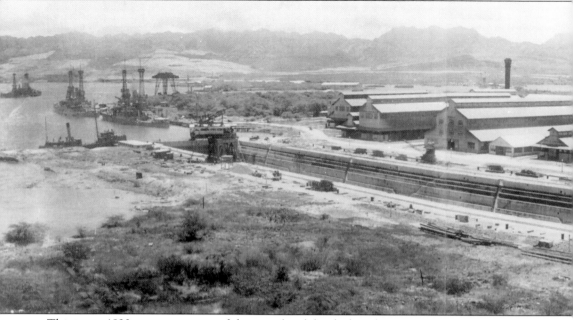

This is a c. 1920 panoramic view of the completed dry dock with concrete paving in place. The contractor's plant has been removed. Most of the shipyard buildings are complete, but many,

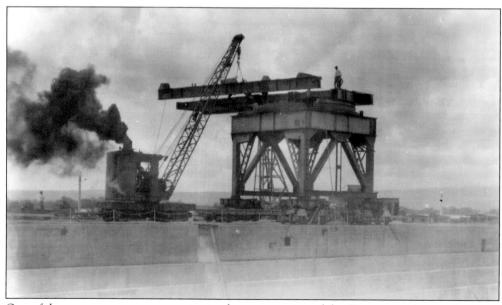

One of the narrow-gauge cranes assists in the construction of the 50-ton portal crane for use at the dry dock. The portal crane was supported on four-wheel trucks of three-foot gauge, allowing for dual use of the installed track by both the portal crane and the shipyard's narrow-gauge equipment. (NPS.)

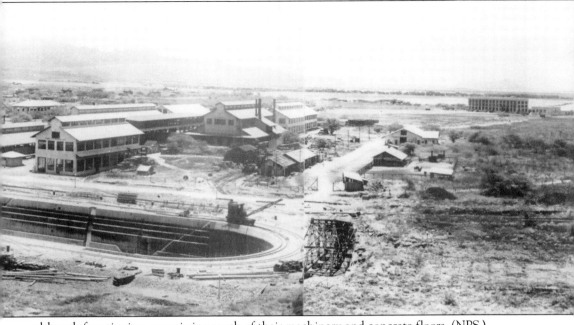

although functioning, are missing much of their machinery and concrete floors. (NPS.)

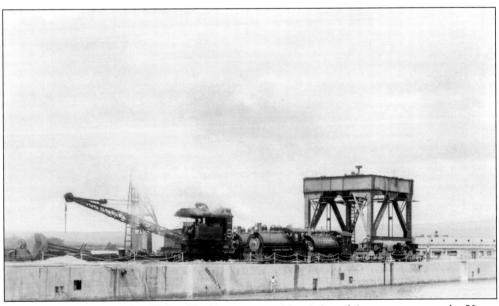

Locomotive Crane No. 10 and Navy Yard Locomotives Nos. 1, 2, and 6 prepare to move the 50-ton portal crane to its final assembly position at the dry dock. All available narrow gauge navy yard locomotives are in use for the move. (NPS.)

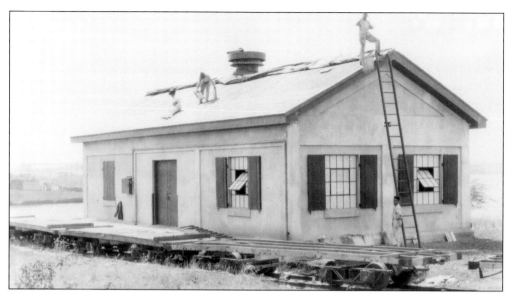

In 1923, the Navy's photographer documenting the reroofing of one of the buildings at Kuahua also captured four of the naval magazine's original link-and-pin flatcars. The manufacturer of these cars remains unknown. Note the use of queen beams only and the lack of queen posts. (NPS.)

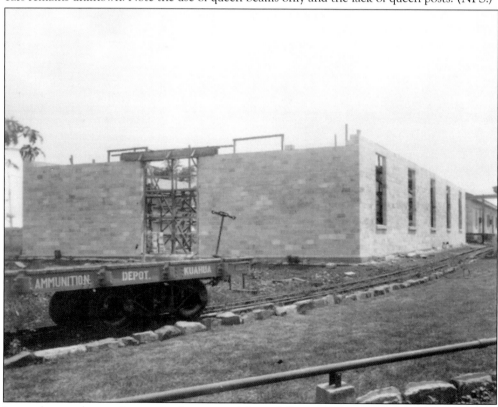

Later, the naval magazine received some steel-framed flatcars. This one appears to be a Gregg product. Documentation of the early freight car acquisitions by the shipyard and Kuahua as well as later orders is unavailable. (NPS.)

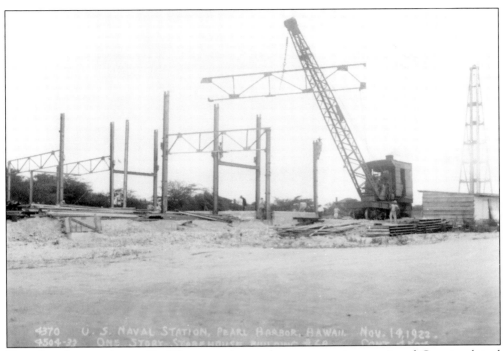

Even though many shipyard buildings were incomplete, construction continued. Structural steel is being erected for a new one-story storehouse in this 1923 photograph. (NPS.)

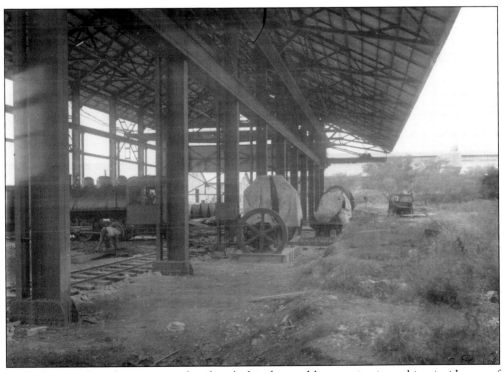

With floors and machinery yet to be placed, this shipyard locomotive is working inside one of the shipyard buildings on temporary track. (NPS.)

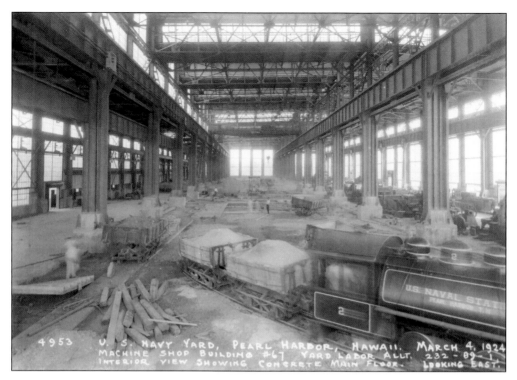

Pictured here is Navy Yard No. 2 working inside the machine shop during installation of the concrete flooring in March 1924. By April, most of the flooring was complete and ready for installation of the machinery. Little railroad access remained, and that was about to be eliminated other than that planned to allow transfer of material from the overhead crane to a railroad car. (Both, NPS.)

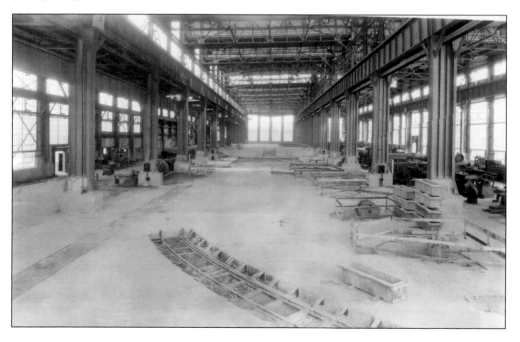

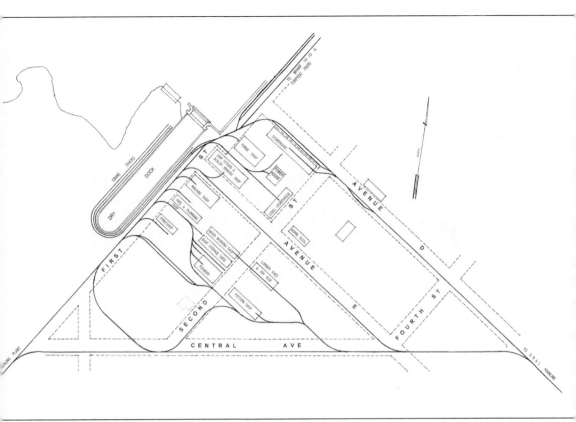

This Shipyard Industrial Area Track Plan was traced from a portion of a US Naval Station T.H. map showing improvements to June 30, 1920. The industrial tracks connected to the coaling plant and extended along the shoreline to the new submarine base and via a causeway to the naval magazine on Kuahua Island. (Stanley Kumura.)

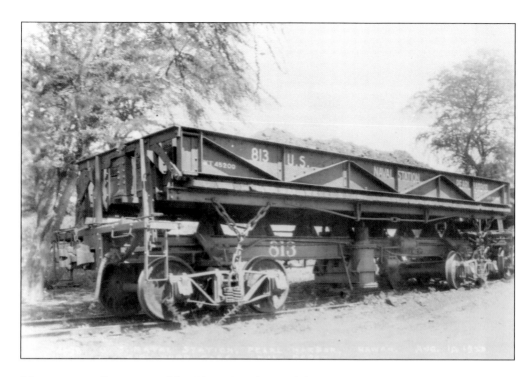

These two excellent views of the Oliver 20-cubic-yard dump cars date to around 1923. Note the change in lettering from "US Naval Coaling Plant Pearl Harbor" to "US Naval Station Pearl Harbor." The coaling plant was now simply a part of the fuel depot. (Both, NPS.)

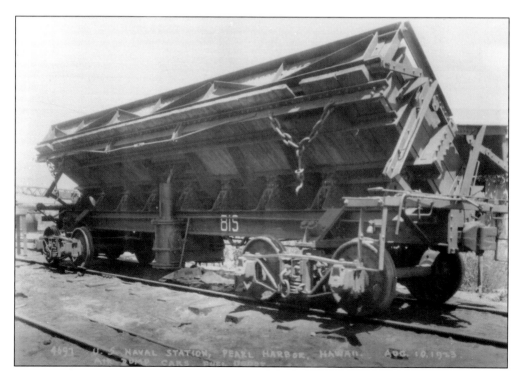

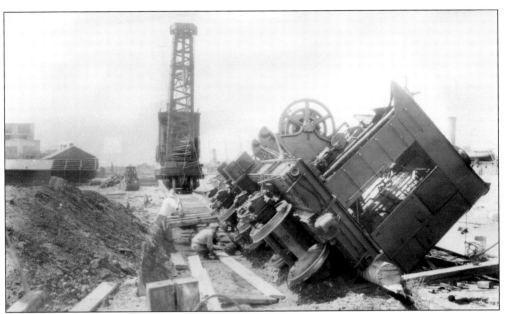

Cranes can and do tip over, but from the orientation of the cab, it seems that a load did not bring Navy Yard No. 11 to grief. The boom had been removed by the time this photograph was taken. Perhaps it ran off the rails or the rails failed beneath it. (NPS.)

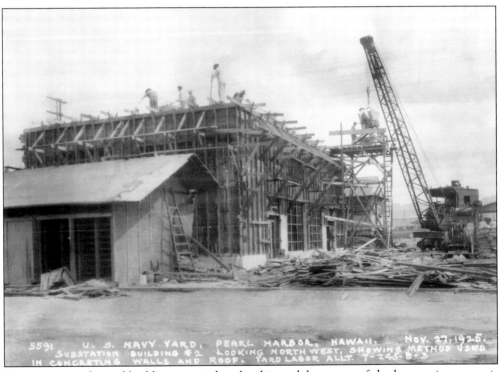

Concrete was a favored building material at the shipyard; here, one of the locomotive cranes is hoisting the bucket during the 1925 construction of an electrical substation. (NPS.)

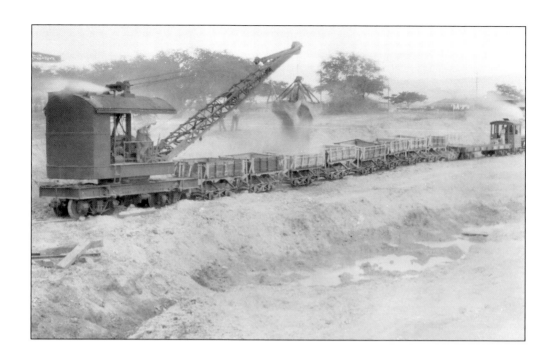

As the shipyard continued to grow, grading of streets and roadbed was an ongoing project. Some of the 47 well-worn dump cars seen above had been in use since 1909. The shipyard at last installed a small railroad yard around 1927 as the number of carloads of material received through the Oahu Railway and Land Company continued to increase. Only shipyard locomotives and crews were allowed to operate within the shipyard. (Both, NPS.)

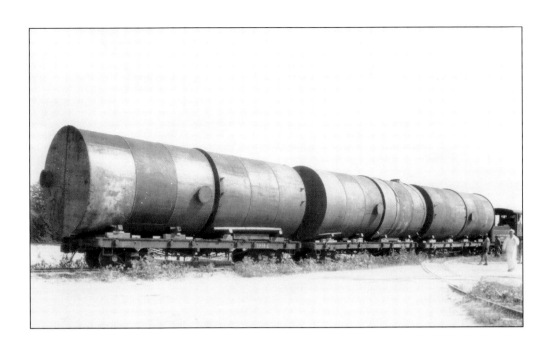

As naval propulsion systems continued to evolve, diesel fuel began to supplant heavy fuel oil just as heavy fuel oil had taken over from coal. To keep up with the changing requirements, the shipyard built and installed a diesel-oil purification system in approximately 1928. These tanks arriving on Oahu Railway and Land Company flatcars were offloaded by a shipyard crane close to the 10-10 wharf for installation. Above, Navy Yard Locomotive No. 9—former US Army 0-6-0 Porter No. 9130, built in 1920—is barely visible to the right. (Both, NPS.)

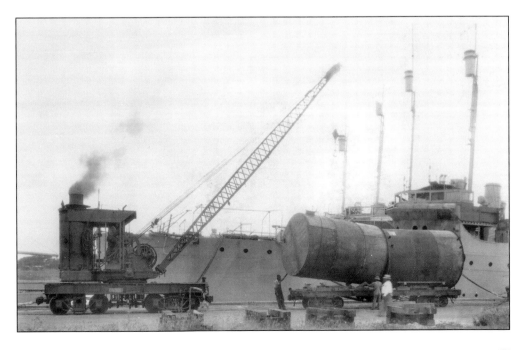

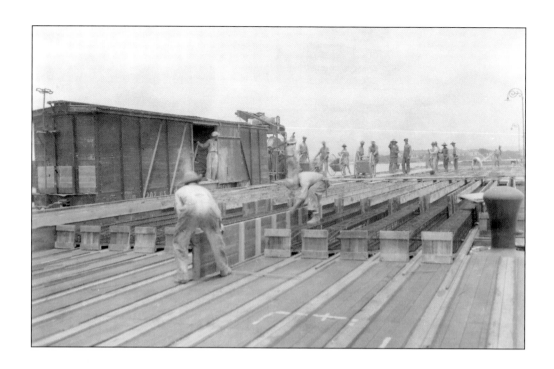

The ever-increasing construction of piers and wharfs at Pearl Harbor required an extensive number of concrete pilings driven into the muddy bottom to support the concrete decks and equipment. Again, the shipyard's rail equipment was necessary to the successful manufacture of these pilings. (Both, NPS.)

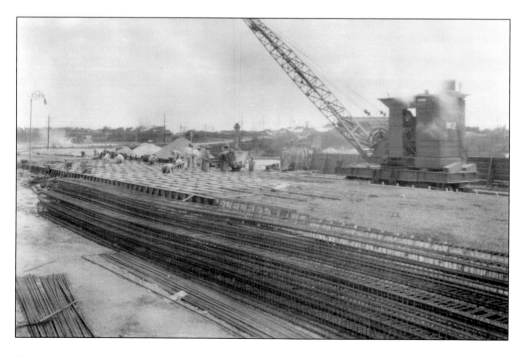

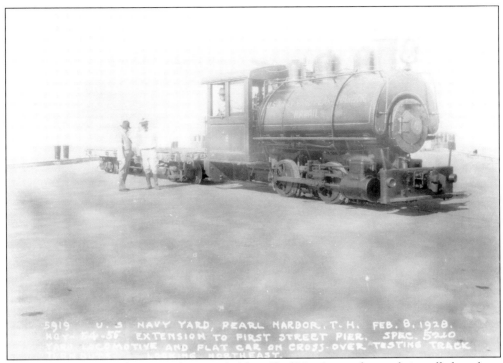

In this companion to the cover photograph, Navy Yard No. 6 tests the newly installed track on the First Street pier in February 1928, this time with flatcars in tow. (NPS.)

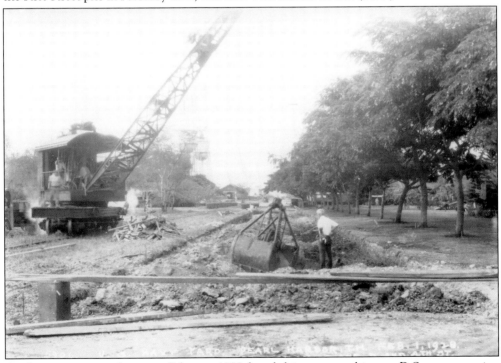

Grading never seemed to stop. February 1928 found this crane working on D Street, preparing the sub-roadbed for eventual paving. (NPS.)

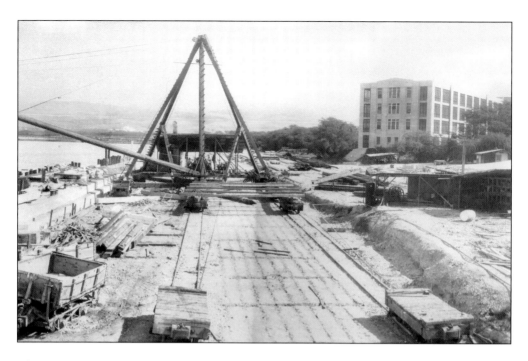

The submarine base, begun in 1918, was a temporary affair made up of tents, a few wood buildings, and one submarine support ship. By the mid-1920s, all that had changed with the construction of an expansive wharf, finger piers, and permanent structures, including a large barracks. (Both, NPS.)

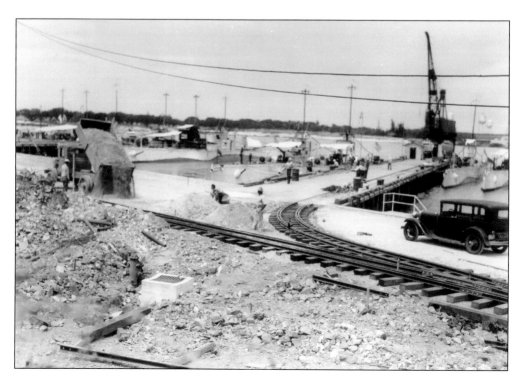

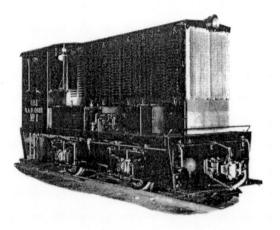

35-TON DIESEL ELECTRIC LOCOMOTIVE

United States Navy Department, Pearl Harbor, Hawaiian Islands

PERFORMANCE:	Tractive effort, starting, lbs. (25% adhesion)		17,500
	Tractive effort, continuous, lbs. (Self-ventilated)		3,300
	Speed at continuous T.E. m.p.h.		17.3
	Maximum safe speed m.p.h.		25.0
	Approximate free running speed m.p.h., light loco.		22.0

ELECTRICAL EQUIPMENT:	Generator	Westinghouse	1-type 183-D-2, 500 volts.
	Motors	Westinghouse	2-type 939-CH, 500 volts, 140 hp. each
	Motor Gear Ratio		14:79
	Control	Westinghouse	Single end, electro-pneumatic, series-parallel, motor field shunting.

MECHANICAL EQUIPMENT:	Locomotive Builder		Atlas Car & Mfg. Co., Cleveland, Ohio.
	Engine	Westinghouse	4 cyl., Diesel, type 4-F-1, 265 hp., 900 rpm.
	Brakes	Westinghouse	Straight and Automatic Air Schedule 14-EL.
	Compressor		Gardner Denver, gear driven, 74 cu.ft.
	Radiator		Forced ventilated by mechanical driven fan.

DIMENSIONS:	Track Gauge	36"
	Truck Wheel Base	8'0"
	Length, face to face coupler knuckles	21'7-1/2"
	Width, overall	8'0"
	Height, Overall	11'0"
	Wheel Diameter	38"

DESCRIPTION OF OPERATION:	General switching and haulage inland from Pearl Harbor, over 11-mile narrow gauge railroad. Two locomotives used in this service.

Westinghouse Equipped Oil Electric Locomotives
Provide Reliable Low Cost Transportation Service
for Railroads and Industry.

Ask the nearest Westinghouse Office for Details.

The first diesel electric locomotives in Hawaii were two 35-ton Atlas locomotives ordered in 1933 for use at the new naval magazine at Lualualei and the Naval Ammunition Depot (NAD) West Loch. NAD No. 1 was assigned to Lualualei, and NAD No. 2 to West Loch. Westinghouse was quite proud to supply the electrical equipment, as shown in this catalog cut sheet. (National Archives, San Bruno.)

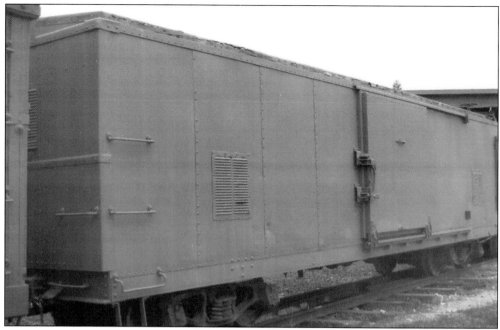

In addition to the Atlas locomotives ordered for Lualualei and West Loch, three steel boxcars and five steel flatcars were ordered from Koppel Industrial Car & Equipment Company. Two boxcars and three flatcars were assigned to Lualualei, and the remainder went to West Loch. No in-service photographs have been located of the boxcars, but two are preserved at the Hawaiian Railway Society. (HRS.)

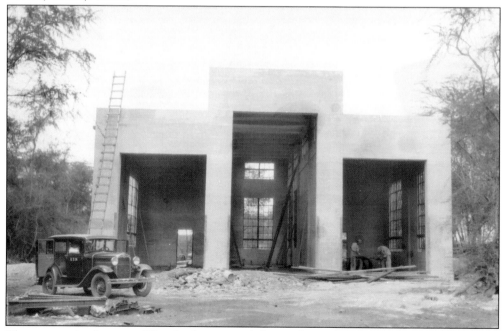

The new engine house at West Loch was much larger than was required for one locomotive. The compressed-air locomotive from Kuahua was transferred to West Loch, and an Industrial Brownhoist locomotive crane was also added. (NPS.)

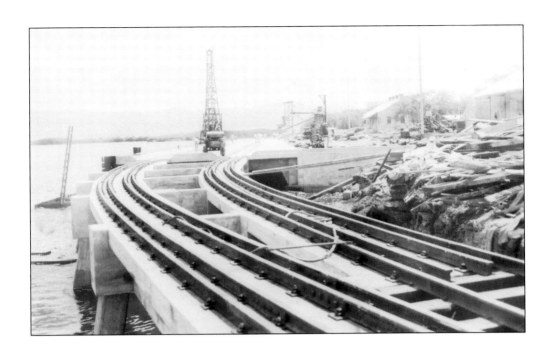

Lualualei was landlocked, so all ammunition transfers took place at West Loch. A large wharf was constructed to service ships, and multiple railroad tracks were included to move munitions. Both ends of the wharf were accessed over concrete trestles. (Both, NPS.)

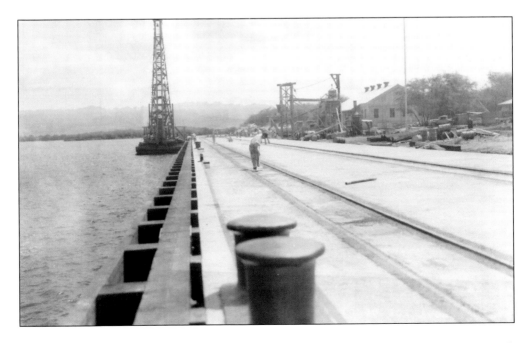

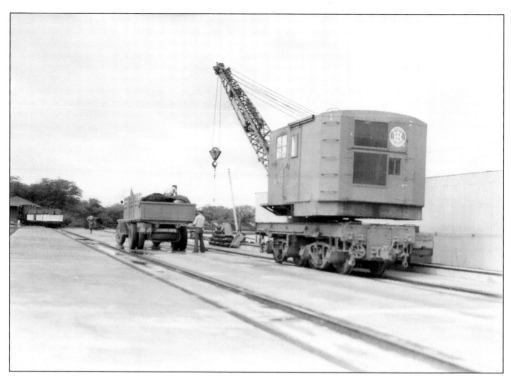

The West Loch locomotive crane unloads Mark 6 mine anchors from a barge for transfer to the assembly buildings. Munitions were assembled and disassembled at West Loch and were also loaded and unloaded from ships alongside. (Both, NPS.)

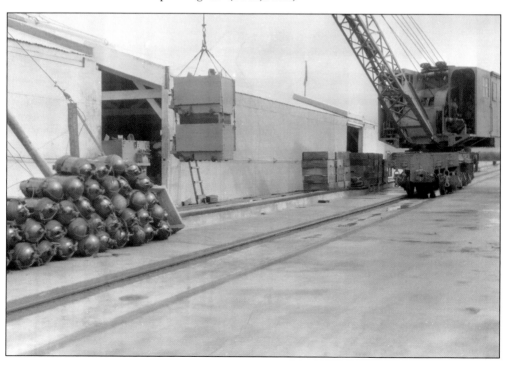

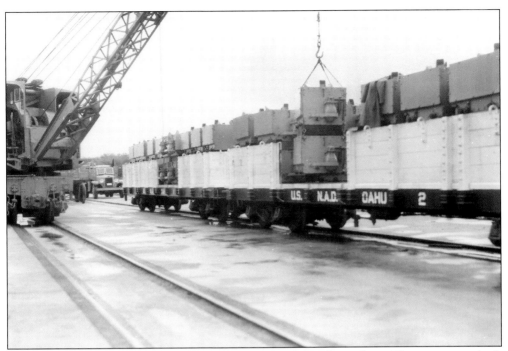

Two of the three Koppel flatcars assigned to West Loch are shown here. These cars were built with steel plate over the wood decks to facilitate movement of the mine anchors. The flatcars at Lualualei had standard wood decks. (NPS.)

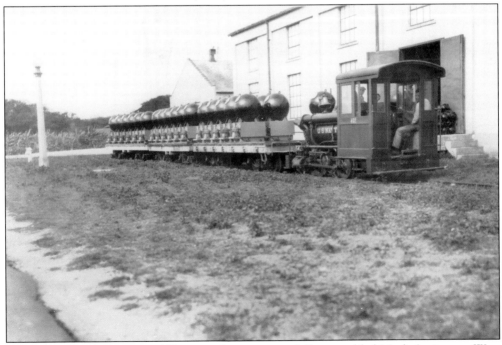

Compressed-air locomotive 403 is seen here moving fully assembled Mark 6 mines at West Loch. This may be a different locomotive than the one originally assigned to Kuahua. One was transferred from Kuahua around 1933. (NPS.)

Lualualei was primarily a storage facility for munitions components, which were transferred to West Loch for assembly and delivery. With the Navy's limited railroad-equipment resources, the Oahu Railway and Land Company provided most munitions transportation. These boxcars are significant in that this is one of the few photographs with the short-lived "See Oahu by Rail" logo. (NPS.)

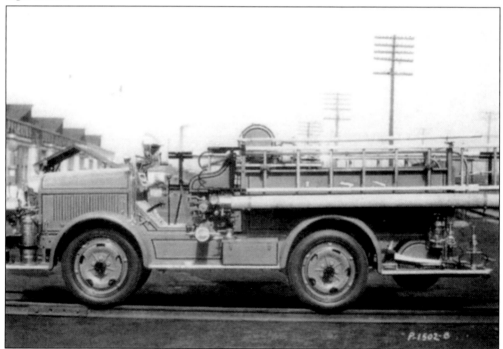

Lualualei did have one very unique piece of railroad equipment: this 1934 Pirsch rail fire engine. The large area covered by the naval magazine required the ability to fight potential fires where no water was available. (Fire Trucks at War.)

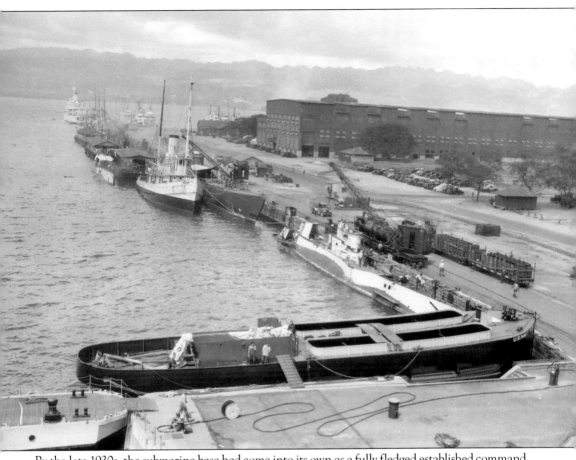

By the late 1930s, the submarine base had come into its own as a fully fledged established command. Here, a shipyard crane is performing a submarine main storage battery replacement. (NPS.)

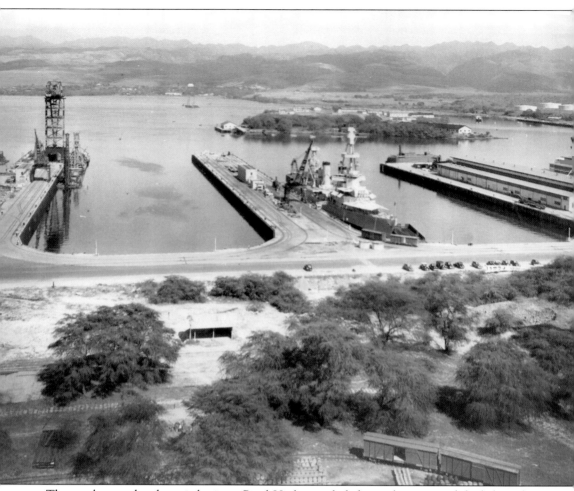

The newly completed repair basin at Pearl Harbor included portal cranes and dual three-foot tracks for the shipyard's rail equipment. Kuahua Island, home of the original naval magazine, can be seen in the background. (NPS.)

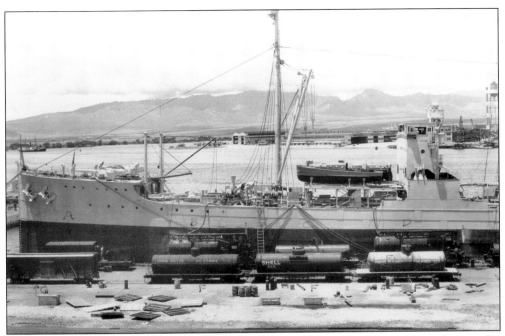

In 1935, the shipyard acquired a "Wheeler" tank-cleaning system and mounted it on flatcars. On these photographs, "A" marks the hose car, "B" and "D" are vacuum units, "C" is a Navy tank car for settling and transfer, "E" is a Navy locomotive to provide steam for cleaning, "F" marks Oahu Railway and Land Company flatcars with Shell Oil Company tanks for waste oil and sludge, and "G" is a crew car. (Both, NPS.)

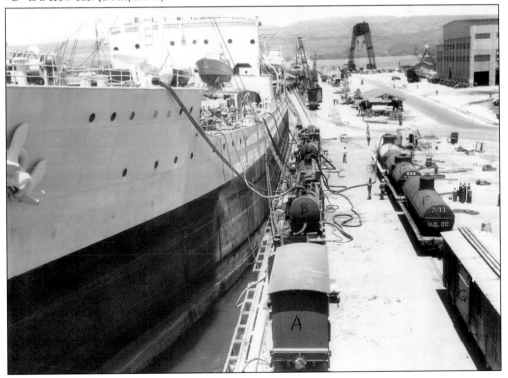

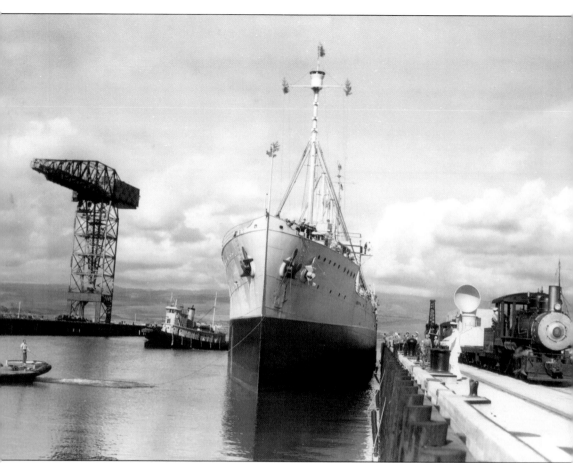

Tank cleaning completed, Shipyard Locomotive No. 9, formerly Army No. 9130, is shown to better advantage delivering material to the USS *Neches*. The shipyard's 200-ton hammerhead crane can be seen in the background. (NPS.)

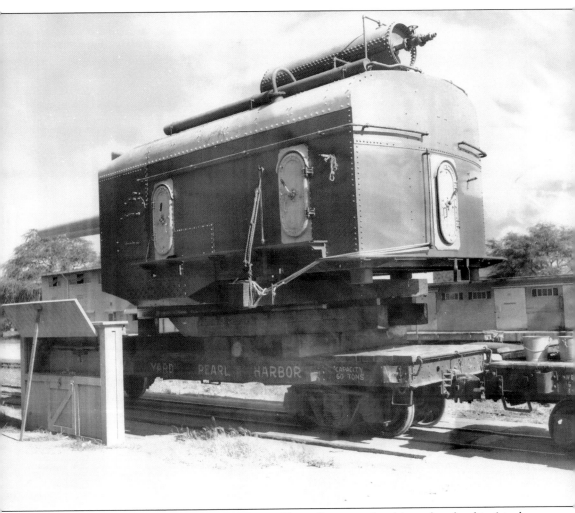

Pictured in February 1939 resting on a Gregg 60-ton flatcar at the shipyard scale, this 6-inch, 53-caliber Mark 16 Mod 1 gun turret has been removed from the USS *Trenton*, an Omaha-class light cruiser. (NPS.)

Locomotive cranes continued to lead the way in accidents. Fortunately, this narrow-gauge unit was not working on the elevated coaling plant when it fell and crushed the cab of the Navy utility truck. The lineman working on the pole is unfazed. (Both, NPS.)

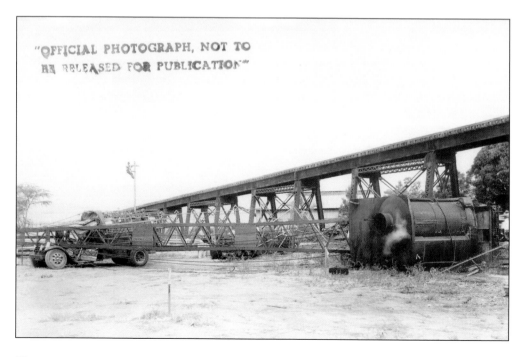

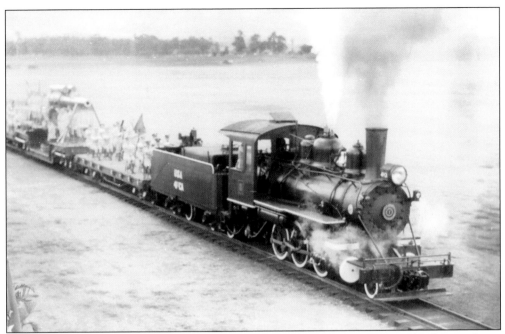

This Baldwin 2-6-0 construction No. 57789 was received by the Army in 1925 for the 41st Coast Artillery (Railway). Originally delivered with a sloped-back tender, the locomotive was used to move the 12-inch railway mortars and later the 8-inch railway guns shown here from Fort Kamehameha to various firing points around Oahu. (US Army Museum of Hawaii.)

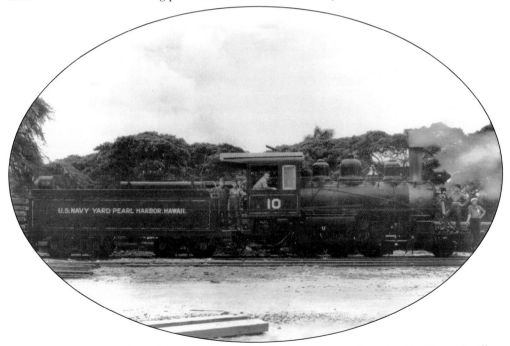

The Oahu Railway and Land Company provided the locomotives when the 41st Coast Artillery was required to move its equipment around the island; in 1939, their locomotive was transferred to the shipyard, becoming Navy Yard No. 10. (NPS.)

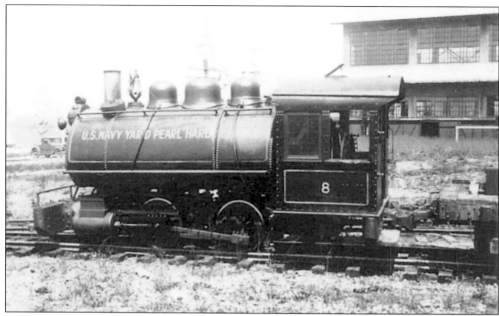

Navy photographers took few photographs of railway equipment while documenting the construction of the shipyard and Pearl Harbor, which makes this in-service photograph on Navy Yard No. 8 somewhat of a rarity. (John Goldie collection.)

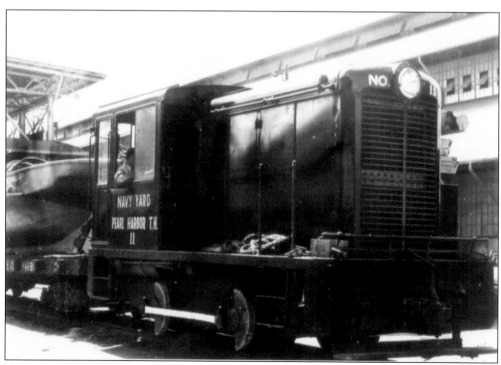

Navy Yard No. 11 (construction No. 2308), a 35-ton Davenport diesel mechanical locomotive received in late 1940, was the shipyard's first diesel locomotive and the first new locomotive since 1918. (NPS.)

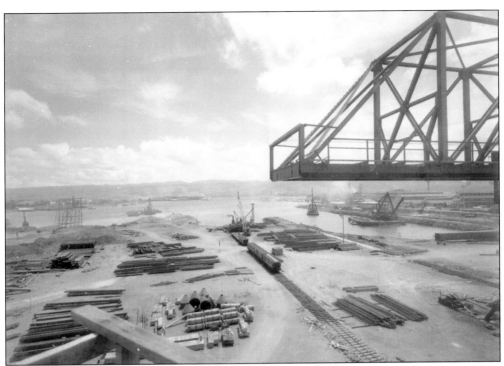

In 1940, with war in Europe and rising concerns in the Pacific, the Navy embarked on numerous construction projects at Pearl Harbor. Chief among them was the building of two new dry docks: Nos. 2 and 3. Once again, the contractors established their plants, and the dredges went to work. This time, the Oahu Railway and Land Company supplied most of the railway equipment rather than the contractors. (Both, NPS.)

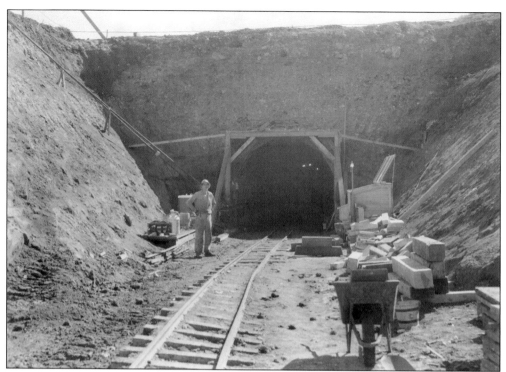

Fuel, munitions, and food are critical to fleet operations. In 1940, construction began on a huge underground fuel facility at Red Hill, adjacent to Pearl Harbor. While excavation was begun at Red Hill, a tunnel was driven from the submarine base to Red Hill 450 feet below the surface. One of the muck cars shown below is preserved at the Hawaiian Railway Society. (Both, NPS.)

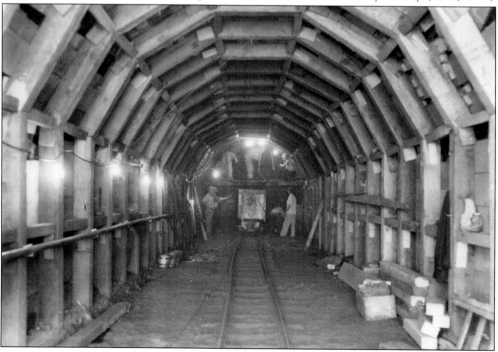

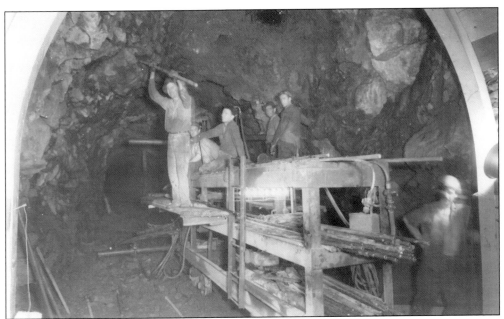

Tunneling through the bedrock of Oahu was a challenge, and the two-foot-gauge underground railroad played an important part in construction. Below is one of the Goodman battery-powered locomotives, one of which is preserved at the Hawaiian Railway Society. The Red Hill fuel facility would eventually consist of 20 underground vertical tanks with a capacity of 252 million gallons. (Both, NPS.)

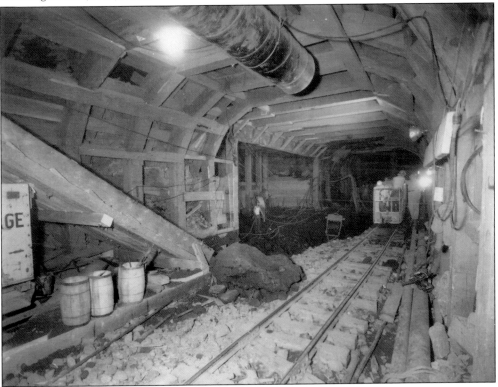

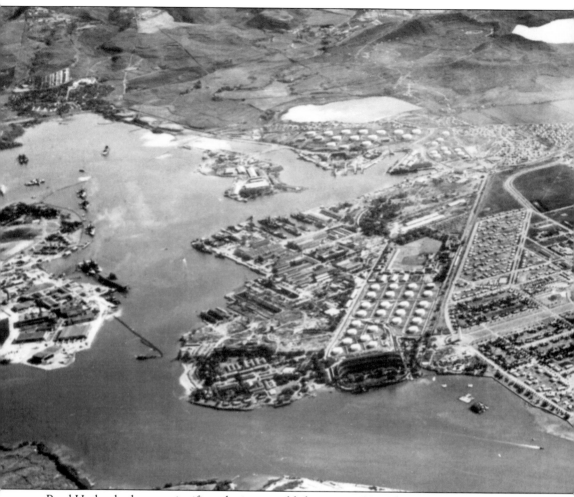

Pearl Harbor had grown significantly since establishment in 1908. This prewar aerial view shows the shipyard, including the shops, two new dry docks, marine railways, and the repair basin. Also shown is Kuahua Island, which was quickly becoming a peninsula with fill from Red Hill and the new Naval Air Station on Ford's Island. (NPS.)

Three

WORLD WAR II
1941–1945

Following the attack on Pearl Harbor, both the Navy and the Army found themselves critically short of the necessary railroad equipment to meet the emergency. While orders for new narrow-gauge locomotives and freight cars were quickly placed, filling these orders would take months and years. The OR&L did its best to fill the gaps, but demand quickly overwhelmed the available equipment. To fill the immediate needs, old, used narrow-gauge equipment from the mainland was gathered up and sent to Hawaii, arriving in the condition it was found in early in 1942. Later, used equipment was refurbished prior to shipment. The government also commandeered a large lot of new narrow-gauge boxcars built by Pullman-Standard for the Argentine State Railway and sent them to Pearl Harbor. The Navy quickly acquired two small plantation locomotives locally, one from Oahu Sugar Company and the other unknown. A 2-8-0 was also brought from the mainland for the shipyard and converted to 0-8-0 to handle the shipyard curves. The OR&L also received used equipment from the mainland including one additional locomotive. As the numbers of railcars increased, so did demand, and control became an ever-increasing problem. July 1944 marked the establishment of the District Rail Transportation Coordinator (DRTC), which took control of all Navy railcar movements within all Navy establishments and Navy cars operating over the OR&L. This included over 500 new boxcars and gondolas from the Pressed Steel Car Company received mid-1944 and 10 new diesel electric locomotives received later that year. New locomotives were also received at Lualualei and West Loch. By war's end, in addition to the equipment being used solely by the Navy and the Army, the OR&L had over 325 Navy-owned freight cars in its general pool and over 150 under lease from the Army. The DRTC had leased one diesel electric locomotive to the Kahului Railroad on Maui and on at least two occasions leased locomotives to the OR&L. Even with all this new equipment shortages still existed, and it was a constant struggle for the Navy, Army, and OR&L to meet demand.

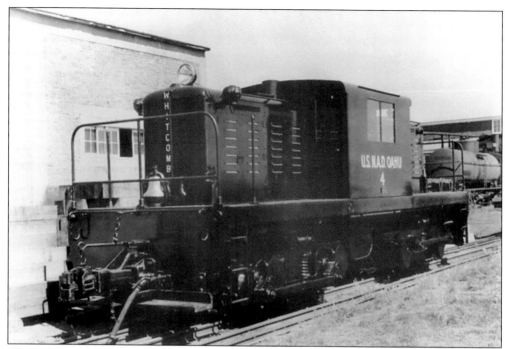

The naval ammunition depot fared slightly better than the shipyard, with two 40-ton Whitcomb diesel electric locomotives arriving just prior to the war. These units became NAD Nos. 3 and 4, augmenting the two 35-ton Atlas locomotives just in time. (HRS.)

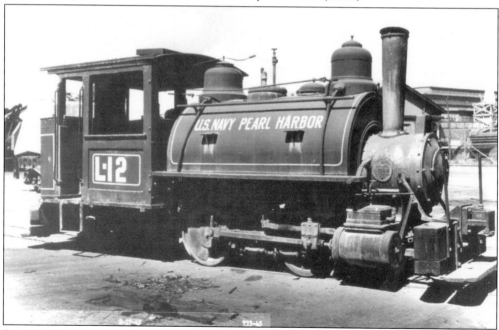

Faced with an overwhelming need for railroad equipment, the Navy looked first locally for equipment. Navy Yard No. 12 was acquired from an as-yet-unknown source (most certainly a plantation). No other information is available. This photograph was taken in 1946 after the prefix "L" was applied to the navy yard locomotives. (Pearl Harbor Naval Shipyard.)

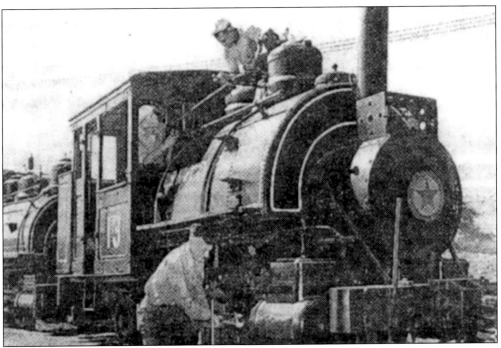

Locomotive No. 13 was acquired from the Oahu Sugar Company. This venerable Baldwin built in 1897, construction No. 15310, had been Oahu Sugar No. 2—*Waipio*—until drafted for the duration. (Pearl Harbor Naval Shipyard.)

Used narrow-gauge equipment began to arrive from the mainland in early 1942. These boxcars "fresh off the boat" arrived in Honolulu and were moved to the Oahu Railway and Land Company yard for further transfer to Pearl Harbor. (Bill Blewett, HRS.)

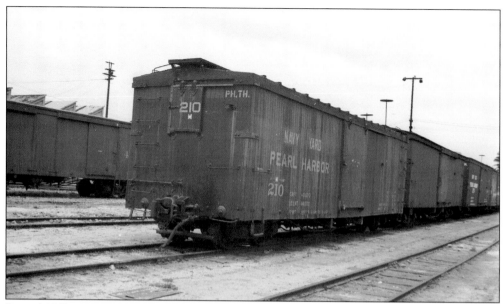

By mid-1942, cars arriving to augment the equipment at Pearl Harbor were being refurbished to some degree on the mainland prior to being shipped. One example is this former Denver & Rio Grande Western 3000-series boxcar. In all, the Denver & Rio Grande Western sold three refrigerator cars, ten boxcars, and eighteen flatcars to the Navy in February 1942. (Bill Blewett, HRS.)

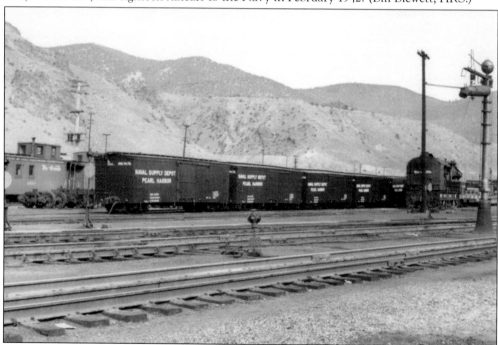

A string of freshly overhauled used boxcars for Pearl Harbor awaits shipment from Salida, Colorado, around 1942. The Navy bought much of its used freight equipment from scrap dealers and not from the railroads that originally owned the equipment. These were acquired from the Chicago Freight Cars Parts Co. and were mostly from the Colorado & Southern Railroad. (Colorado Railroad Museum.)

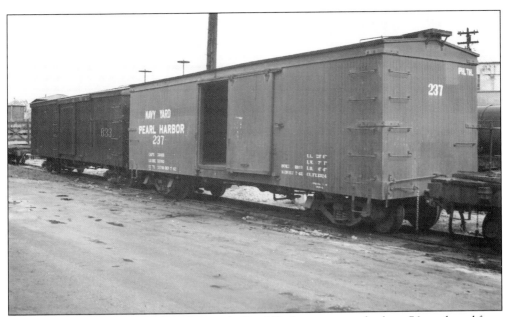

This former Colorado & Southern boxcar for Pearl Harbor was one of at least 76 purchased from the Colorado & Southern and overhauled by contractors at the Denver & Rio Grande Western shop at Gunnison, Colorado. (Bill Blewett, HRS.)

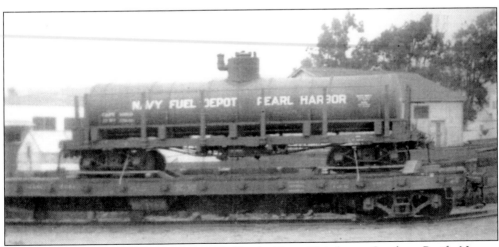

Boxcars were not the only equipment needed by the Navy. This former Southern Pacific Narrow Gauge tank car was one of 10 sold to the Navy for the fuel depot in March 1942. Four of these tank cars had gasoline-powered transfer pumps added in South San Francisco prior to shipment. (Herman Darr collection.)

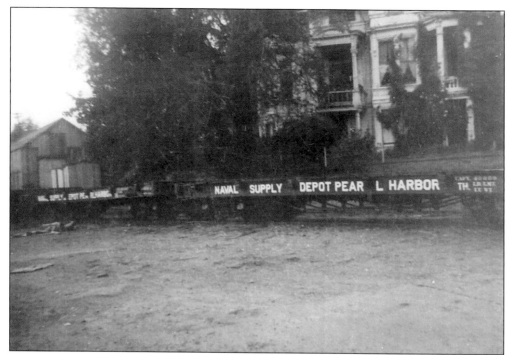

Former Nevada County Narrow Gauge equipment also found its way to Hawaii during the crisis. These flatcars were photographed at Grass Valley, California, adjacent to the Kidder Mansion just prior to shipment in about 1942. (Nevada County Narrow Gauge Railroad Museum.)

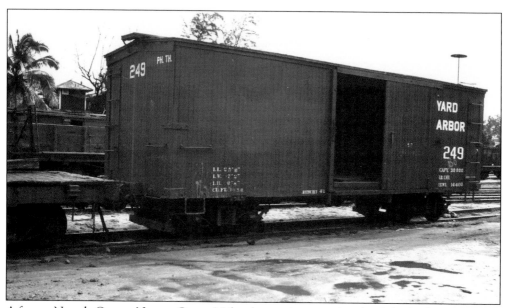

A former Nevada County Narrow Gauge 26-foot boxcar is pictured in the Oahu Railway and Land Company yard. With photography strictly prohibited within the shipyard, only those cars found at the Oahu Railway and Land Company yard could be photographed. (Bill Blewett, HRS.)

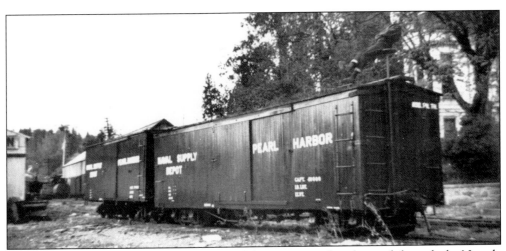

A number of former Florence & Cripple Creek boxcars were also obtained through the Nevada County Narrow Gauge, as illustrated by the car to the left in this photograph taken at Grass Valley, California, in 1943. (Ken Yeo.)

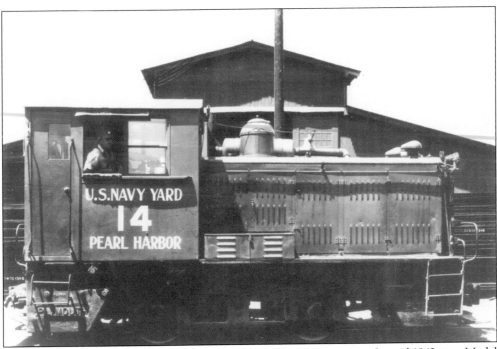

The shipyard did not have to survive on only second-hand equipment. In mid-1942, two Model MLC3 35-ton Plymouth diesel mechanical locomotives arrived. Construction Nos. 4372 and 4373, they became Navy Yard Nos. 14 and 15 respectively. (Pearl Harbor Naval Shipyard.)

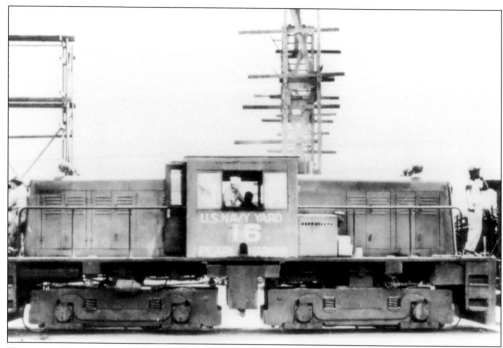

Two new 65-ton Porter B-B diesel electric locomotives for the shipyard were delivered shortly after the two Plymouths. Porter construction Nos. 7355 and 7356, they were assigned Navy Yard Nos. 16 and 18. No. 17 is believed to have been skipped because of a delay in shipping the second locomotive. (Pearl Harbor Naval Shipyard.)

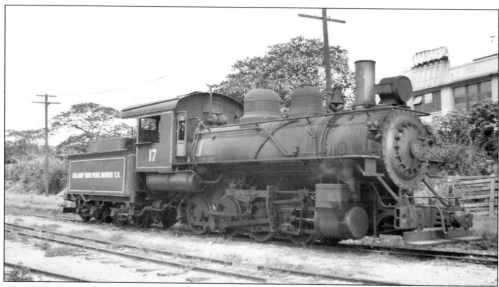

Navy Yard No. 17 was not forgotten. This number was assigned to Baldwin Locomotive construction No. 41300, built in 1914 and also acquired by the Navy in 1942. No. 17 was formerly Nevada County Narrow Gauge No. 9; before that, Southern Pacific No. 1; and earlier still, Nevada-California-Oregon No. 14. This 1942 photograph was taken when it was under lease to the Oahu Railway and Land Company at $75 per day. Note the blackout headlight. (Bill Blewett, HRS.)

New boxcars arrived at Pearl Harbor from the Pullman-Standard Company around late 1942. These were an order placed by the Argentine State Railway and commandeered by the US government. Commonly referred to as "export cars" and "Argentine cars," they arrived as deck cargo and were offloaded at Pearl Harbor. (NPS.)

The export cars were used by both the Navy and the Army and were favored for use on the Oahu Railway and Land Company main line. These cars had steel decks and were considered less suitable for munitions handling than the Oahu Railway and Land Company's older, wood-floor boxcars. (Victor Norton, HRS.)

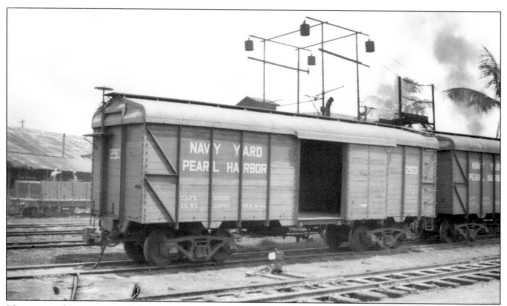

Here is a closer view of the export car type. Each had to be modified with additional safety appliances to operate on the Oahu Railway and Land Company tracks under the Interstate Commerce Commission rules then in effect. Five of these cars, without wheels, are preserved at the Hawaiian Railway Society. (Bill Blewett, HRS.)

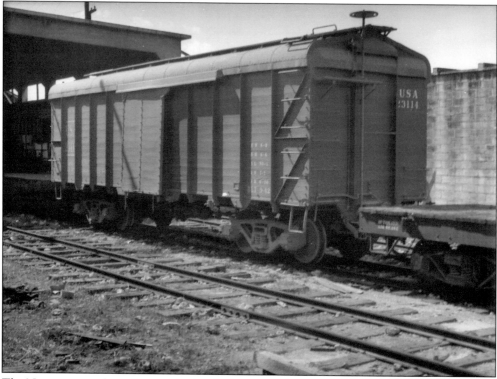

The Navy was not the only organization finding itself short on railroad equipment. This export boxcar was assigned to the Army, as were many others. (Victor Norton, HRS.)

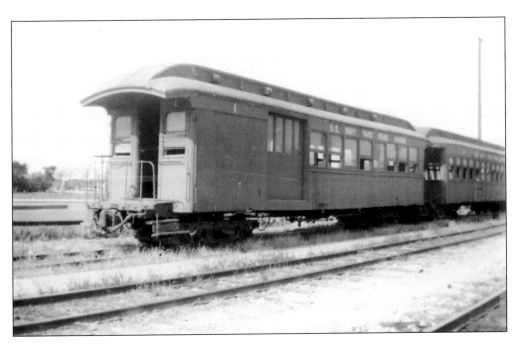

Used passenger equipment was also sent to Pearl Harbor. The former Pacific Coast Railway combine No. 106 found its way to Pearl Harbor to become Navy Yard No. 1 (above), and three coaches were received from the East Broad Top Navy Yard. No. 4 (below) is believed to be ex-East Broad Top Miner's Coach No. 21 or 22. Some of the East Broad Top equipment may have originally been Boston, Revere Beach & Lynn equipment. How this equipment was used by the Navy within Pearl Harbor remains unclear. (Both, HRS.)

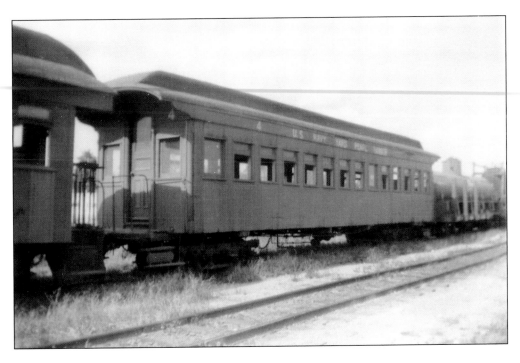

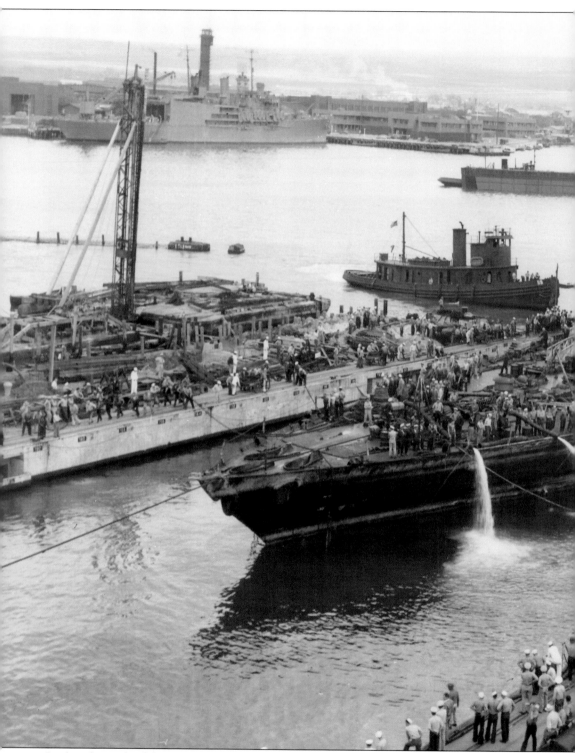

In the aftermath of the Pearl Harbor attack, the shipyard's railroad played an important part in recovery efforts. The USS *California*, sunk on December 7, 1941, enters dry dock on March 25, 1942,

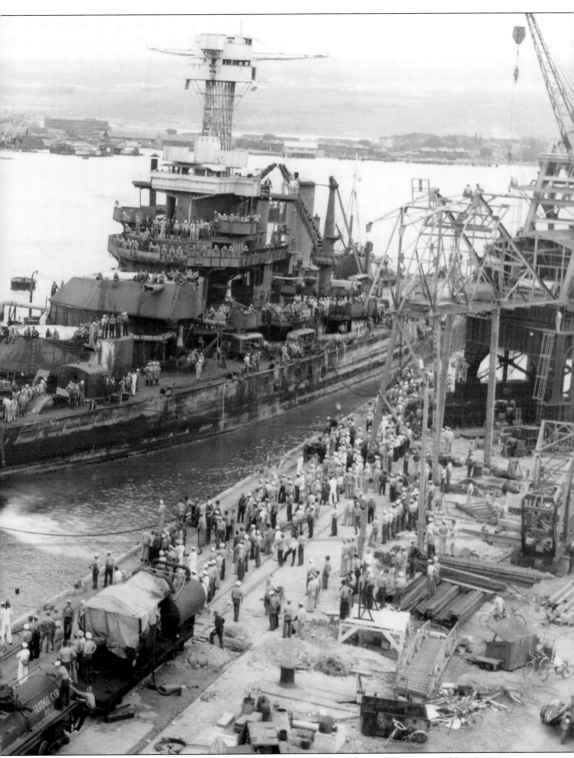

after being refloated. The Wheeler tank-cleaning system and railroad cars stand by. (HRS.)

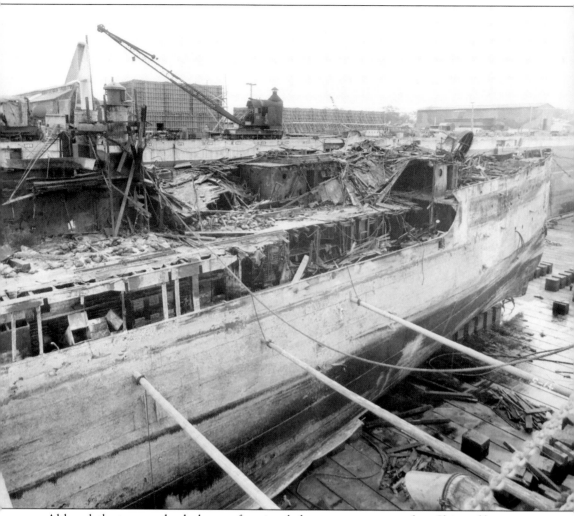

Although the two new dry docks were functional, they were not yet complete. Shipyard locomotive cranes filled in at the dry docks while new portal cranes were being erected. (NPS.)

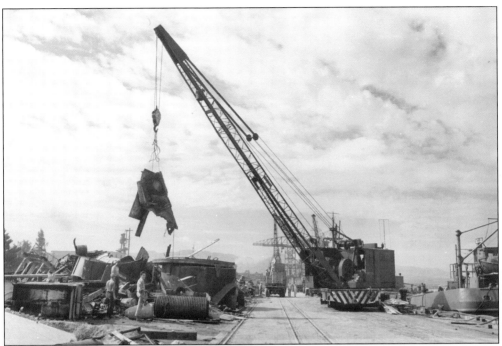

The shipyard had 10 locomotive cranes in 1940. Four more cranes with build dates between 1911 and 1923 were added sometime either just before or just after the attack. One is known to have originally been assigned to the Mare Island Naval Shipyard. New cranes began arriving in 1942, with 12 diesel-powered narrow-gauge cranes received from Orton Crane & Shovel Company that year. The cleanup effort after the attack was massive, and the cranes shown here in January 1943 are loading scrap steel to be shipped to the mainland for recycling. (Both, NPS.)

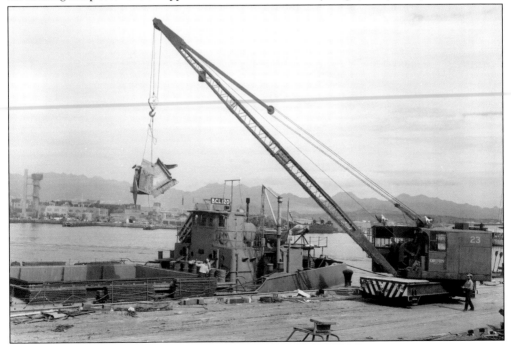

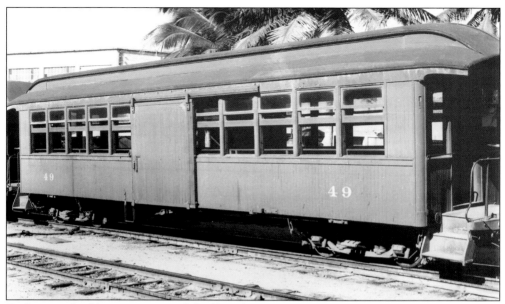

With gas and rubber rationing in full effect, the Oahu Railway and Land Company was called upon to provide greatly increased passenger service in addition to freight service. Older passenger cars that had been converted in the 1930s to "can" cars (above) to act as boxcars to service the pineapple industry were quickly returned to passenger service, often with only bench seating and without the window glass being replaced. During shift changes, trains ran on five-minute schedules. (Above, Fred Stindt, HRS; below, NPS.)

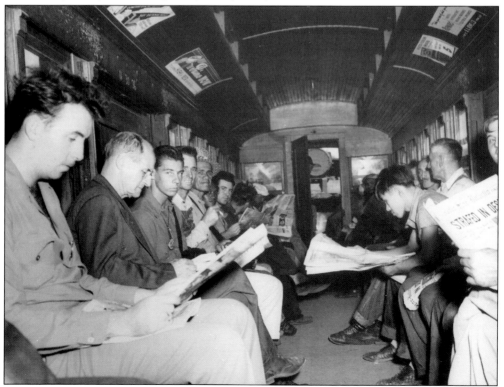

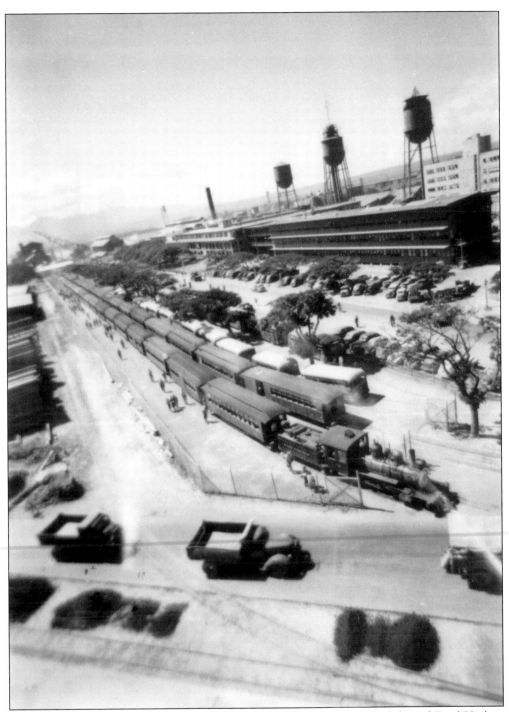

Trains of well over 20 cars carried most of the workforce between Honolulu and Pearl Harbor. This was the first time Oahu Railway and Land Company locomotives were allowed access to the shipyard since the early 1920s. This photograph was taken from the fire station at what are now Central Avenue and Russell Street. Note the security fence on both sides of the trains and busses. (NPS.)

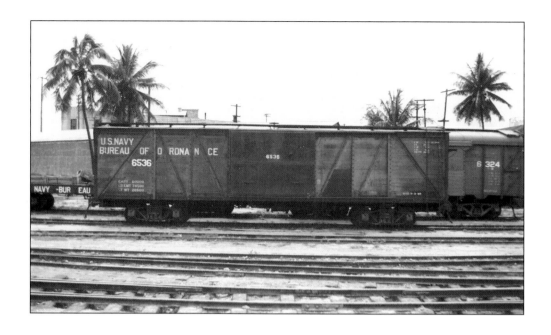

New railroad equipment ordered in 1942 began to arrive in large numbers in 1944. These were mostly boxcars, flatcars/gondolas, and tank cars. The Pressed Steel Car Company supplied the bulk of the flatcars/gondolas and boxcars, as illustrated here. One gondola and a number of boxcars are preserved at the Hawaiian Railway Society. (Both, Bill Blewett, HRS.)

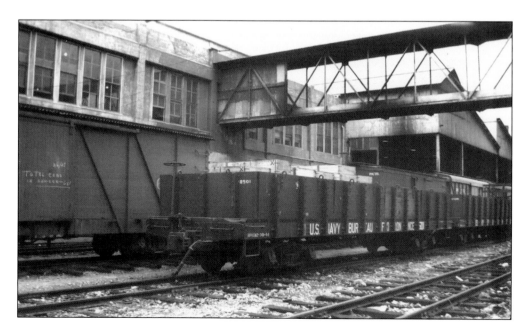

The Bureau of Ordnance was not the only beneficiary of this new equipment; the shipyard also received its fair share and likely then some. This flatcar pictured above in the Oahu Railway and Land Company yard is a good example. The American Car & Foundry supplied a number of tank cars; this is one of two preserved at the Hawaiian Railway Society. (Above, Bill Blewett, HRS; below, HRS.)

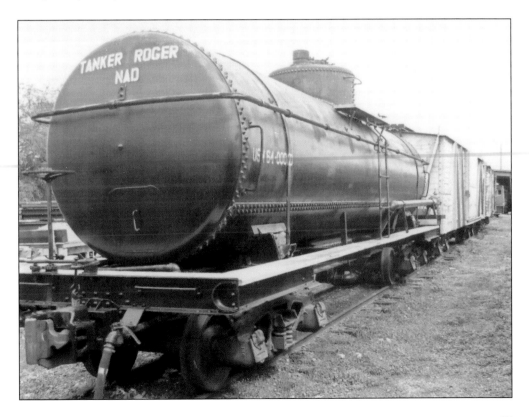

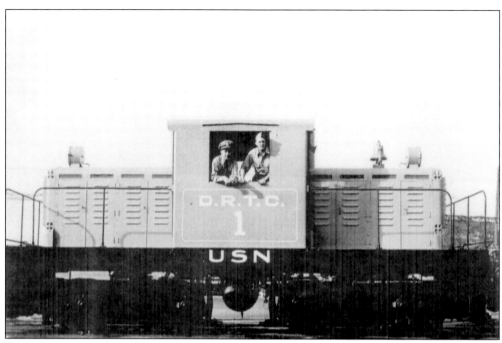

With the large numbers of freight cars arriving on Oahu for both the Navy and the Army, control of shipments and tracking of car locations and use became increasingly problematic. In August 1944, the Navy established the office of the District Rail Transportation Coordinator to monitor all shipments within the naval establishment and the Oahu Railway and Land Company. The DRTC also received and had control of 10 new diesel electric locomotives. Six of them were 45-ton Whitcomb locomotives like these. (Both, Pearl Harbor Naval Shipyard.)

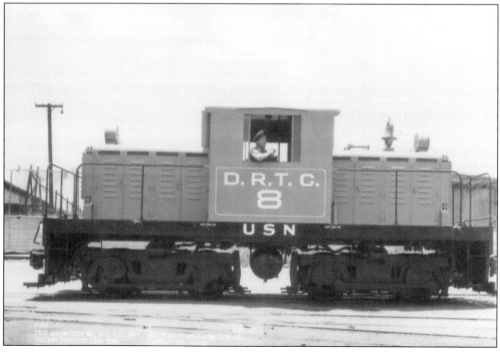

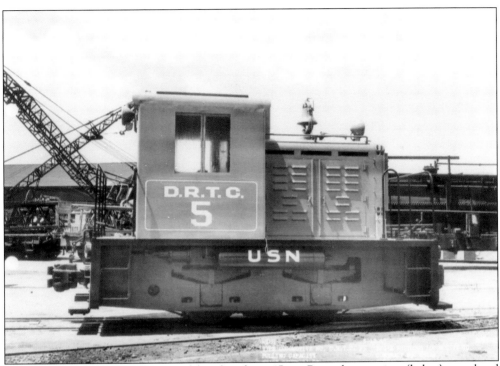

Two 25-ton Whitcomb locomotives (above) and two 45-ton Porter locomotives (below) completed the District Rail Transportation Coordinator's locomotive roster. Exactly how and where all these locomotives were used is unclear. One of the 45-ton Porter locomotives was shipped to Maui to augment the Kahului Railroad. Maui had also already received more than 40 export boxcars. (Both, Pearl Harbor Naval Shipyard.)

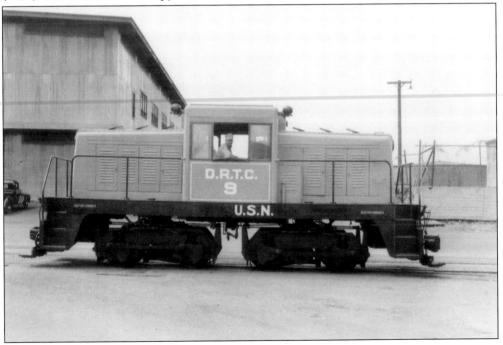

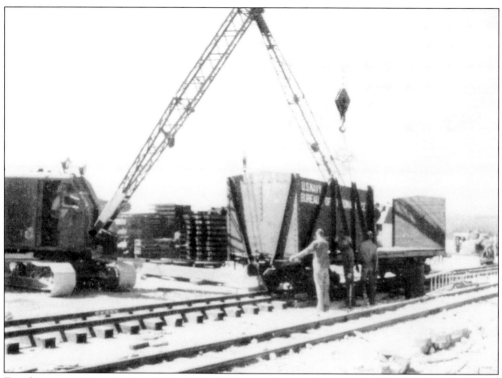

Freight cars arriving in Hawaii in 1944–1945 were shipped disassembled, just as they had been in the earliest years of Pearl Harbor development. At Iroquois Point, 440 narrow-gauge cars were received in late 1945. The 52nd Naval Construction Battalion assembled 170 of these cars in 40 days before sailing from Pearl Harbor. (HRS.)

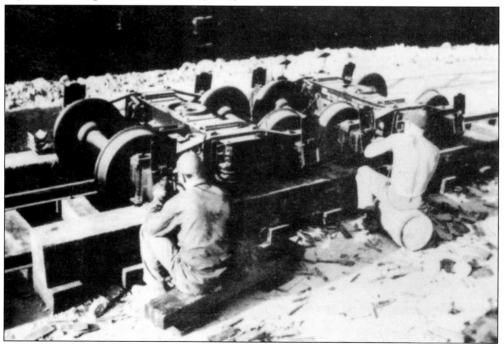

This rare photograph showing Locomotive No. 10 and one of the "Wheeler System" tank cars was taken inside Pearl Harbor during the war. The exact location within the yard is undetermined, and the origin of the locomotive boiler in the right foreground is unknown. (HRS.)

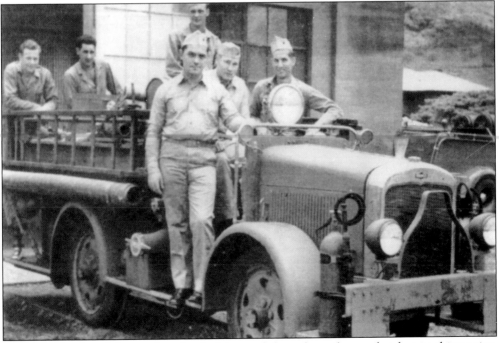

The 1934 Pirsch rail fire truck at Lualualei served throughout the war but lost its shiny paint, pin striping, and bell. All naval facilities had expanded greatly, and the little pumper had been joined by a number of rubber-tired units, as seen in the background.

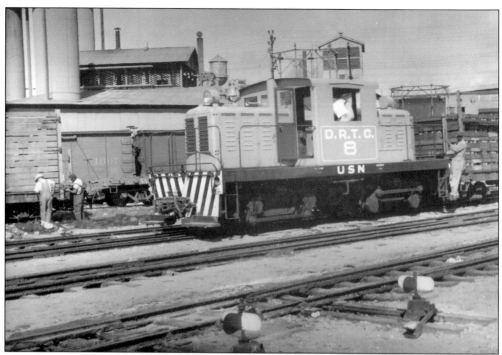

The Oahu Railway and Land Company found itself short of motive power in June 1945 and rented two District Rail Transportation Coordinator 45-ton Whitcomb locomotives, Nos. 7 and 8. These locomotives were used in the yard only and cost $14 per day each, quite a significant price reduction from 1942, when locomotives were in such short supply. (Both, Victor Norton, HRS.)

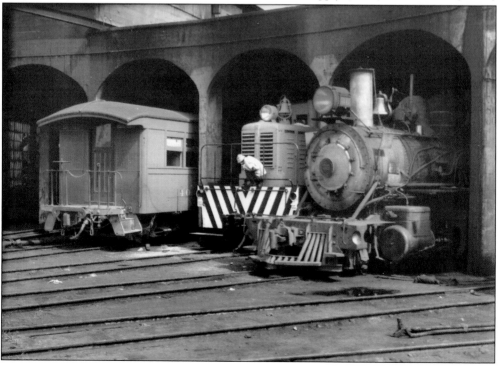

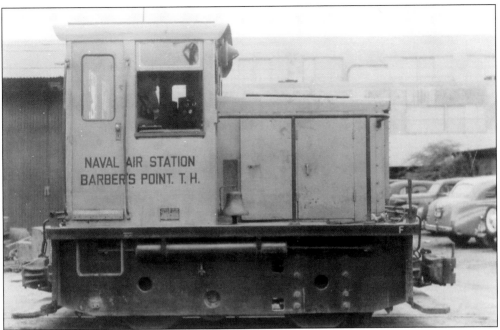

Pearl Harbor, Lualualei, and West Loch were not the only Navy facilities with rail operations. Naval Air Station Barbers Point had a small system whose full extent remains undetermined. The Navy records indicate two 25-ton locomotives were assigned to Barbers Point, but only one identifiable photograph, showing this 25-ton General Electric locomotive, has been located. (US Navy.)

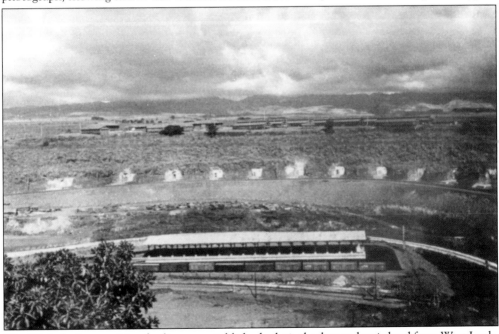

The Waikele Ammunition facility was established relatively close to but inland from West Loch. This was a rail-served facility consisting of 128 bunkers dug into the sides of the hills. While it is likely one or more Naval Ammunition Depot locomotives were assigned to Waikele, no details regarding this railroad's operations have been discovered. (US Navy.)

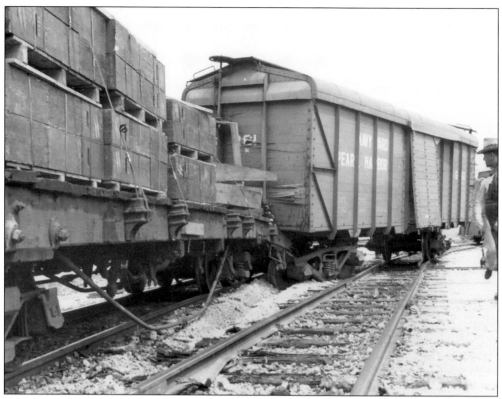

Splitting a switch caused this Navy ammunition train to derail at one of the depots. Great care was taken in handling munitions, and accidents were rare. When munitions accidents did occur, they could be both spectacular and deadly. An explosion at West Loch resulted in the loss of six ships, along with 163 fatalities and 396 injuries. (Both, US Navy.)

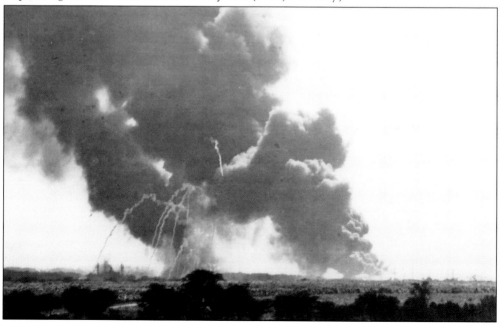

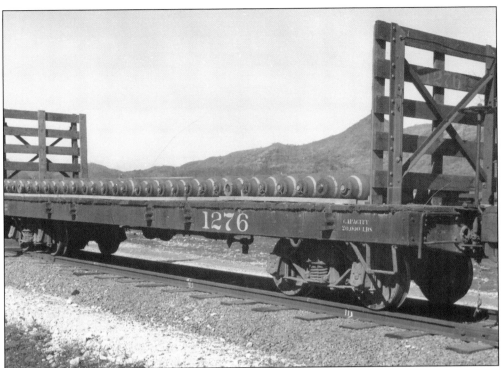

Designed to carry crates of pineapple from the fields surrounding Wahiawa, this Oahu Railway and Land Co. car was pressed into munitions service. These explosives were removed from a ship's flooded magazine and allowed to dry. The Oahu Railway and Land Company's equipment was used extensively by the Navy, with little time for routine maintenance. The decks of these flatcars loaded with munitions at West Loch clearly require replacement. (Both, US Navy.)

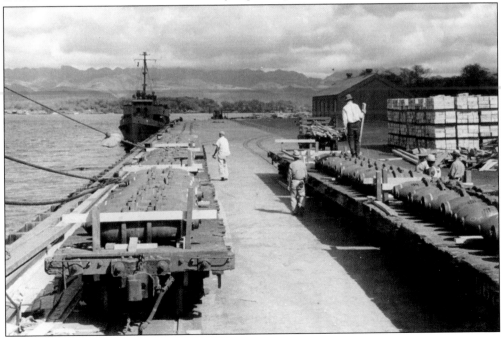

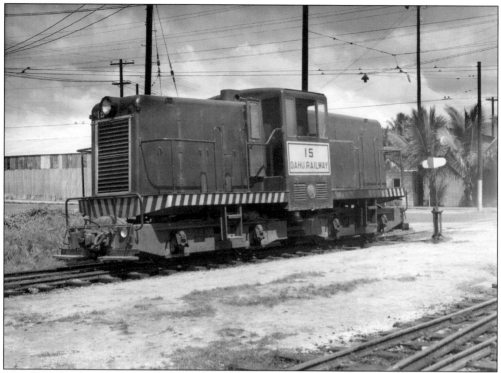

The Oahu Railway and Land Company received no new freight equipment throughout the war but was able to acquire some used equipment. One exception was receipt of two 47-ton General Electric locomotives. (Victor Norton, HRS.)

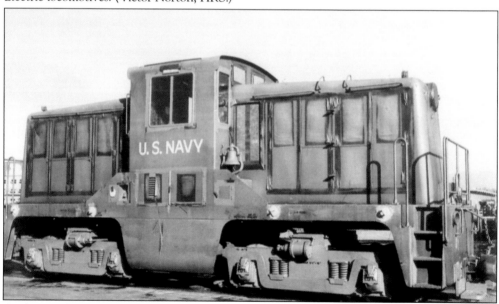

As the war drew to a close, the Navy received three 65-ton Whitcomb locomotives. It is unclear if these locomotives were placed in service before the end of the war, but they marked the end of Navy equipment acquisitions and the last new Navy railroad equipment received in Hawaii. (US Navy.)

Four

THE POSTWAR PERIOD
AND THE END
1946–1970

At the end of World War II, the Navy was operating at least eight steam locomotives, twenty-six diesel locomotives, thirty-two locomotive cranes, and hundreds of freight cars over more than 100 miles of track (not including the Oahu Railway and Land Company's track). With far less demand, the Navy was now faced with an overabundance of equipment far exceeding its peacetime needs. By 1947, all of the steam locomotives were gone. The end of the war also eliminated the need for the District Rail Transportation Coordinator, and the 10 diesel locomotives under its control were redistributed to the shipyard and Naval Ammunition Depot. Some of the smaller diesel locomotives were sold to local plantations that were replacing their aging steam locomotives. The used narrow-gauge equipment was gathered up and moved to remote sidings where it could be found for years after, slowly rotting.

When the Oahu Railway and Land Company abandoned its main line on December 31, 1947, the Navy took an option on the portion of the line connecting Pearl Harbor, Waikele, West Loch, and Lualualei to continue operations. By the mid-1950s, rail operations had ceased at Pearl Harbor, and heavy rains had washed out the rails at Waikele. The Navy eventually gave up the line between Pearl Harbor and West Loch and only operated occasionally between West Loch and Lualualei, a distance of about 12 miles. The rail systems remained very active within Lualualei and West Loch. The last ammunition-train mainline operation occurred in September 1968. The end of 63 years of Navy railroad operations on Oahu came in 1972. The equipment was subsequently turned over to the General Services Administration for disposal.

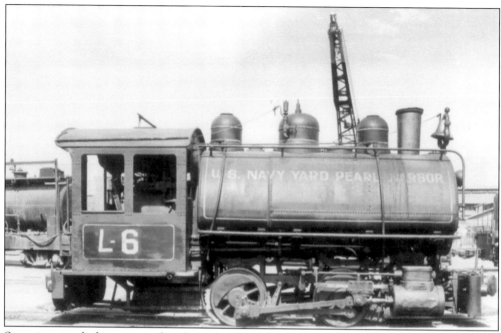

Sometime just before or just after the end of World War II, the shipyard added the prefix "L" to the locomotive numbers and "LC" to the locomotive cranes. L-6, with a hastily applied "L," was photographed in 1946 during what is believed to have been an inventory of equipment. (Pearl Harbor Naval Shipyard.)

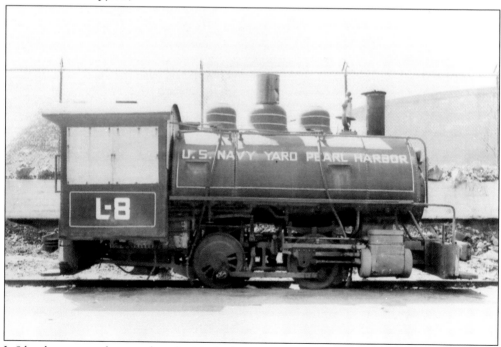

L-8 has been properly renumbered, with the lettering centered on the cab side, but is already out of service and awaiting the fate of all the shipyard's steam locomotives: disposal. Only one would survive, but in a greatly altered state. (Pearl Harbor Naval Shipyard.)

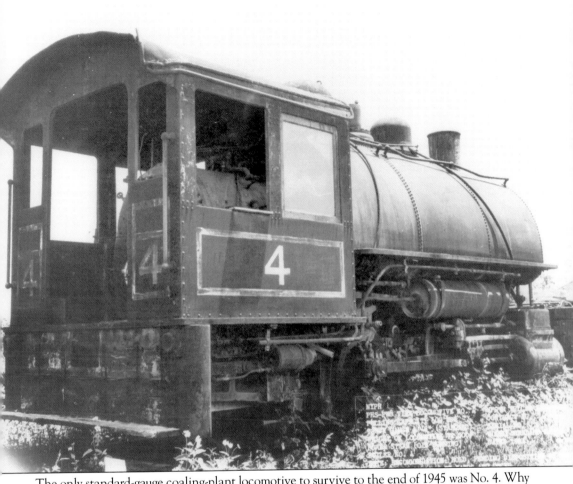

The only standard-gauge coaling-plant locomotive to survive to the end of 1945 was No. 4. Why it was retained and whether it was used during the war is unknown. Exactly when and how the other two standard-gauge locomotives left the shipyard is also uncertain, but No. 5 may have been sold to Carnegie Steel around 1939. (Pearl Harbor Naval Shipyard.)

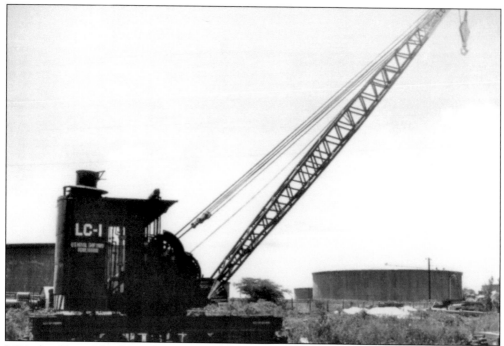

LC-1, the oldest of the shipyard cranes, was still in use in 1946. Her days, as well as her steam-powered sisters, are numbered. Like the steam locomotives, the steam cranes were quickly disposed of and replaced by the newer diesel cranes acquired during the war. (Pearl Harbor Naval Shipyard.)

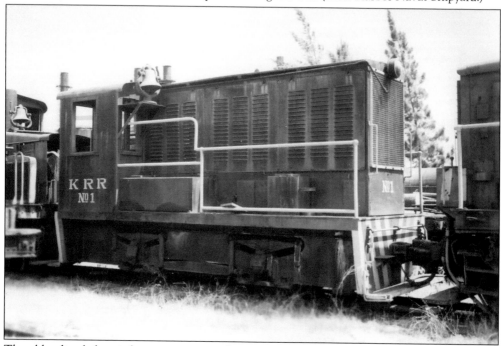

The older diesel electric locomotives were also soon retired but escaped the scrapper for years to come. NAD No. 1 was sold to Hawaiian & Commercial Sugar as its No. 1 and was soon sold to the Kahului Railroad on Maui, again as No. 1. (Roy Okada, HRS.)

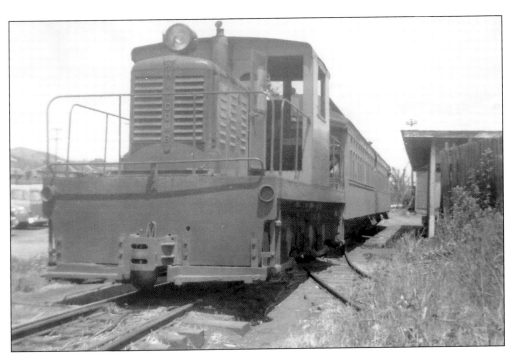

One of the former DRTC locomotives (above) was sold to Kahuku Plantation Co. around 1948. Seen here as the second K.P. No. 1, it is about to depart Kahuku with two ex–Oahu Railway and Land Company passenger cars belonging to the Hibiscus & Heliconia Short Line Railroad, a short-lived railfan group on Oahu's North Shore. By 1955, K.P. No. 1 had been sold to the Northern Railroad of Costa Rica, and the passenger cars burned for scrap. Below, the former NAD No. 3 was sold to US Gypsum Plaster in 1947 and served on the Plaster City Railroad. (Above, Robert Ramsay, HRS; below, HRS.)

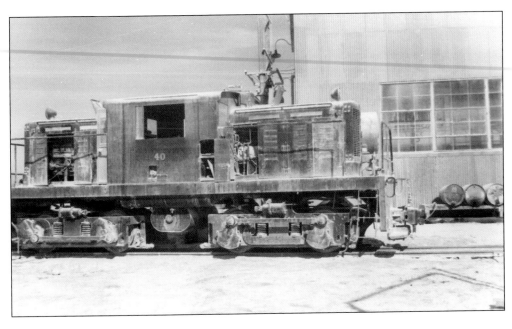

Navy Yard No. 12 (L-12) survived as a stationary steam plant on Ford Island until the early 1970s. Converted sometime after 1946, this was the last remnant of the shipyard's steam locomotive roster. She was scrapped in place when arrangements fell through to save the remains. (HRS.)

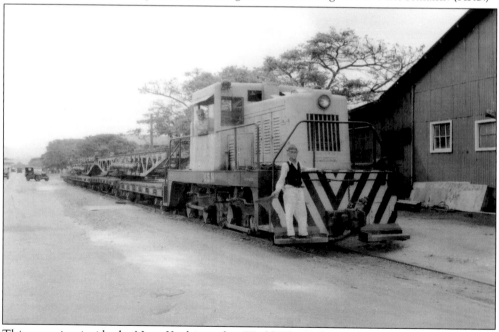

This rare view inside the Navy Yard just after World War II shows No. L-22, one of two 45-ton Porter locomotives built in August 1944, at work moving two aircraft catapults on a four-flatcar consist. L-22 was transferred to the Naval Magazine and later numbered USN 65-00195 and sold around 1961. (Courtesy National Archives and Records Administration.)

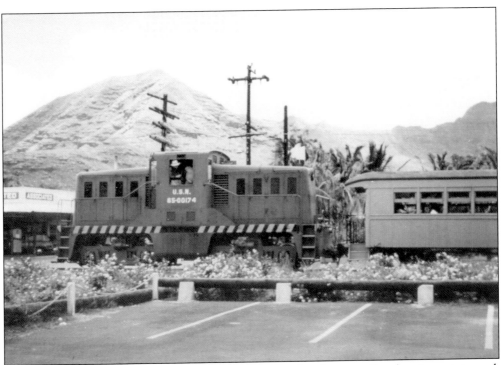

With the beginning of the Korean conflict in June 1950, sales of excess railroad equipment stopped, and photography was again abolished. Rail operations at the shipyard had all but ceased, but the ammunition depots were again quite active. In spite of the war, the Navy operated a fan trip in 1952 for local enthusiasts. (Both, Robert Ramsay, HRS.)

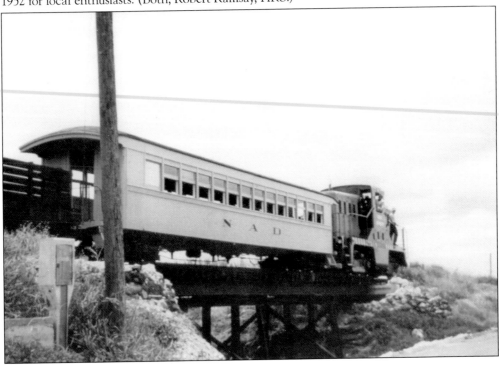

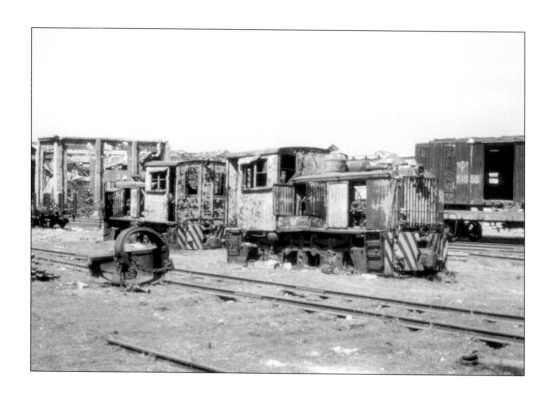

Based on these photographs, Navy Yard L-14 and L-15 were transferred to the Army during the Korean conflict. They are shown here stripped and derelict in Korea in about 1954. The numbers L-14 and L-15 were visible to the photographer. No record of their transfer or information about how or if they were actually used by the Army has been located. (Both, Don Ross.)

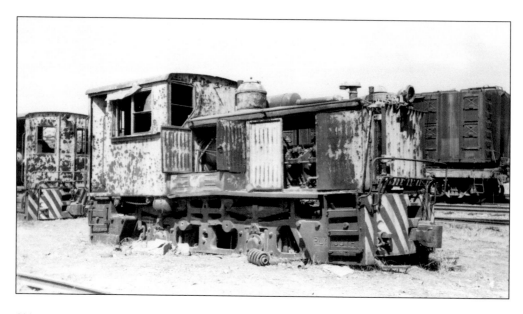

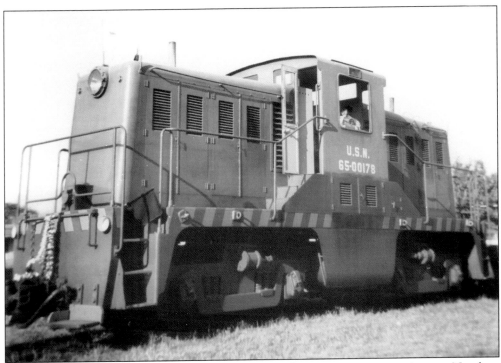

Beginning in 1949, the Navy began renumbering all of its transportation equipment. Numbers prefixed with 65 were reserved for locomotives, while the prefix 61 was for boxcars, as these 1956 photographs illustrate. The locomotives were painted gray, but boxcars on Oahu could be found in gray, red, or black. (Both, Dave Spohr, HRS.)

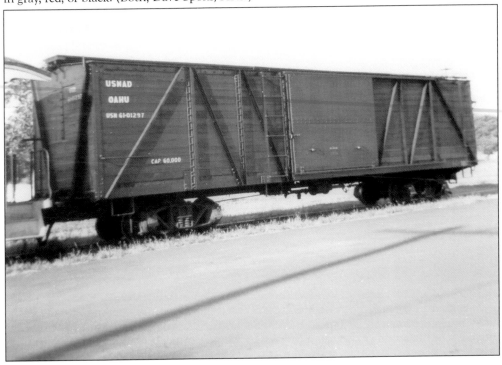

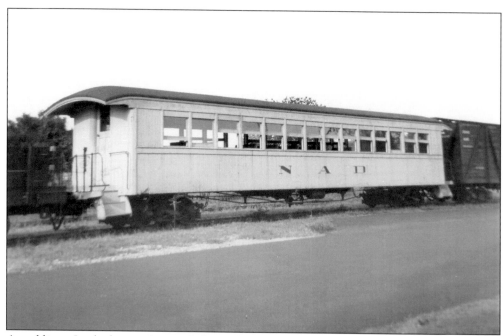

An oddity at Lualualei was this ex–Oahu Railway and Land Company second-class or commuter coach built in 1920. Sold to the US Army Air Force in 1948 for use at Hickam Field, it is unknown how it migrated to the Navy at Lualualei. This car is preserved at the Hawaiian Railway Society. (Dave Spohr, HRS.)

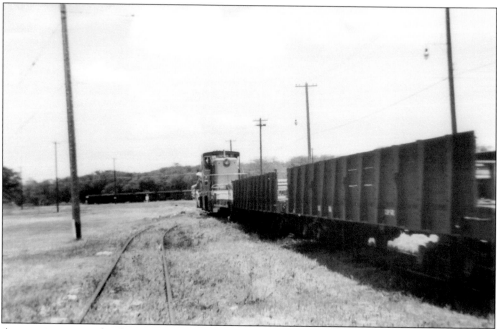

Ammunition transfers between Lualualei and West Loch occurred regularly through the 1950s. Here, a train is being made up at Lualualei for a move to West Loch in 1956. Ammunition was often carried crated in gondolas. A boxcar or empty gondola always separated the locomotive from the first loaded car. (Dave Spohr, HRS.)

Transferring munitions to and from ships could only take place at West Loch, which necessitated the retention of the railroad between Lualualei and West Loch. Above, 45-ton Whitcomb 65-00423, ex-DRTC No. 8, is alongside USS *Bataan* (CVL-29) with an ammunition train around 1950. Below, USN 65-00302, ex-DRTC No. 3, is bringing a load of torpedoes to the USS *John S. McCain* (DL-3) in 1957. Both of these locomotives are preserved at the Hawaiian Railway Society. (Above, R.O. Hale photograph, courtesy M.D. McCarter Collections; below, Ray Crist, HRS.)

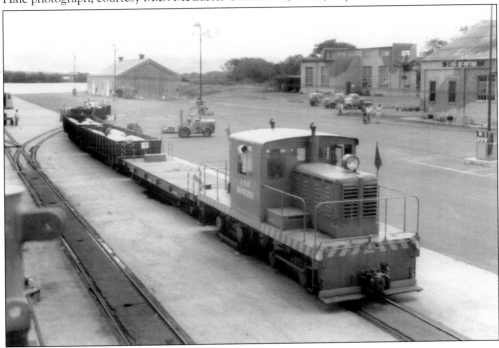

Sales of surplus equipment began again in 1961. These ex-Navy locomotives are awaiting shipment to new owners at Sand Island near where some of them started their careers at Pearl Harbor. At least two are believed to have ended their service life in Saudi Arabia rebuilding the Hedjaz Railroad. (Both, Elliott Whiton.)

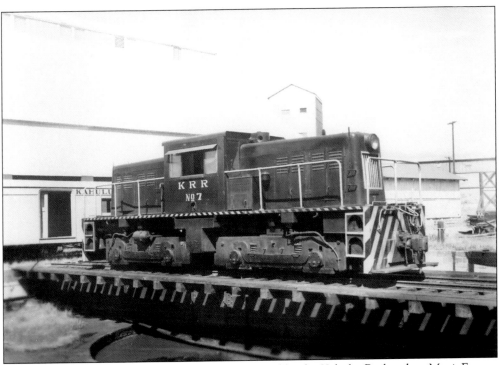

Two locomotives, both 45-ton Porters, were purchased by the Kahului Railroad on Maui. Former Shipyard No. L-16 (above) became Kahului Railroad No. 7. Former L-18 became No. 8. The Kahului Railroad had been loaned a 45-ton District Rail Transportation Coordinator Porter during World War II, and the railroad made the most of this opportunity in 1961. (Both, Roy Okada, HRS.)

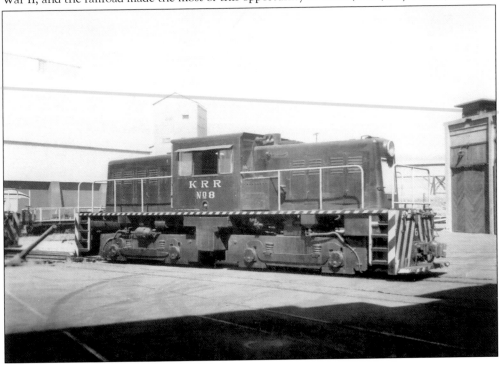

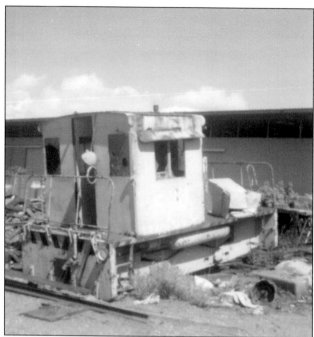

One locomotive found an Oahu buyer. This 25-ton Whitcomb, 65-00198, was purchased by Flynn Lerner and used for spare parts for one of its magnetic cranes. Her remains rest at Pier 35 in Honolulu in this 1972 photograph. (Bob Paoa, HRS.)

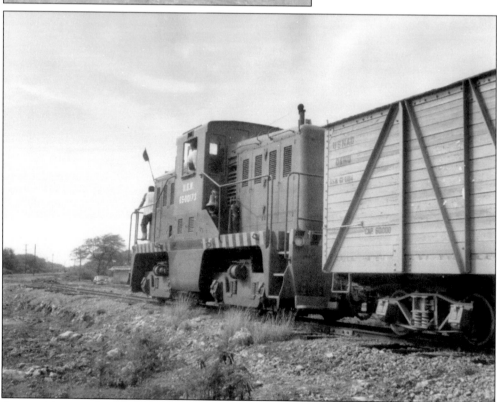

Ammunition transfers continued through the 1960s, but with ever-decreasing regularity. Whitcomb 65-00173 is moving an ammunition train at Kahe Point about midway between Lualualei and West Loch in this 1961 photograph. (Elliott Whiton.)

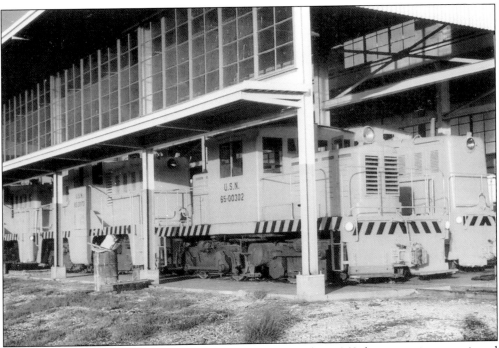

The last train between Lualualei and West Loch occurred in 1968, but operations continued sporadically at both locations. The engine house was full of well-maintained and operational locomotives of both 45-ton and 65-ton capacity in this 1970 photograph. (George Gross, HRS.)

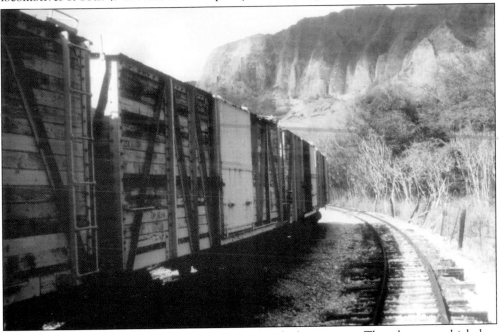

The other rolling stock was not as well maintained as the locomotives. These boxcars, which date to around 1944, were showing their age by 1970 but were still serviceable. Many of the freight cars were spotted far away from the engine house on sidings, where they suffered under the Hawaiian sun. (Herb Deeks, HRS.)

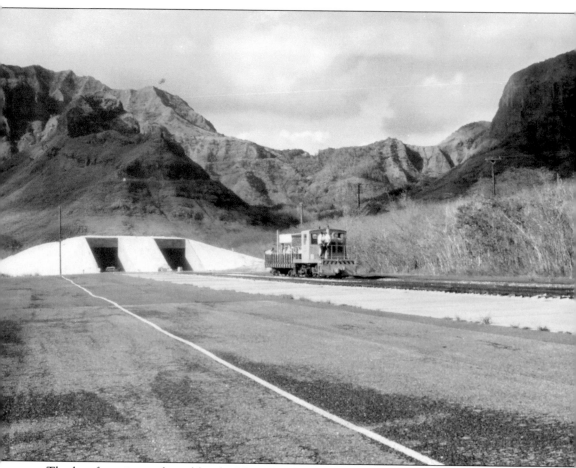

The last fan trip conducted by the Navy for the local railfans was in 1970. Members of the newly formed Hawaiian Railway Society were given a tour of the Lualualei facility, including the magazine areas. (Herb Deeks, HRS.)

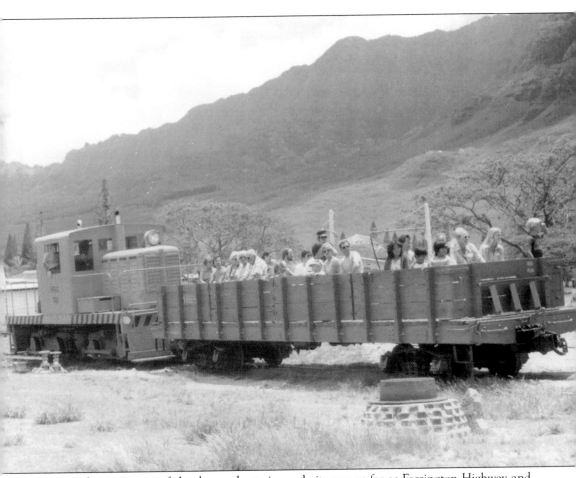

Leaving the main gate of the depot, the train made its way as far as Farrington Highway and the now-unused connection with the old Oahu Railway and Land Company main line. (Herb Deeks, HRS.)

All operations ceased in 1972, and all railroad equipment was turned over to the General Services Administration for disposal. Three of the remaining five 45-ton and two of the remaining 65-ton Whitcomb locomotives were sold to Dulien Steel Inc. of Seattle, Washington, and as in 1961, awaited shipment from Sand Island. (Both, HRS.)

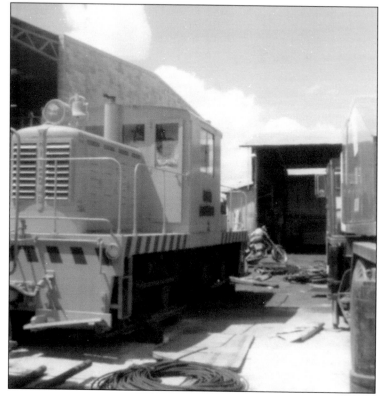

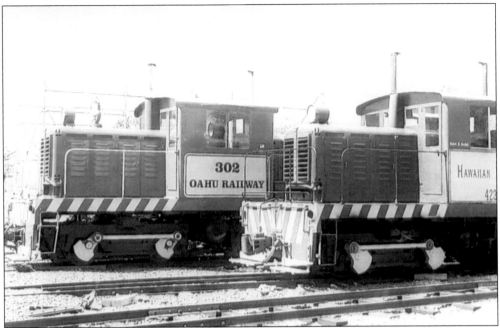

The remaining two 45-ton Whitcomb locomotives, 65-00302 and 65-00423, were donated to the Hawaiian Railway Society, where they have remained in regular operation as Nos. 302 and 423. Both are ex–District Rail Transportation Coordinator locomotives, Nos. 3 and 8 respectively. (Phil Chase, HRS.)

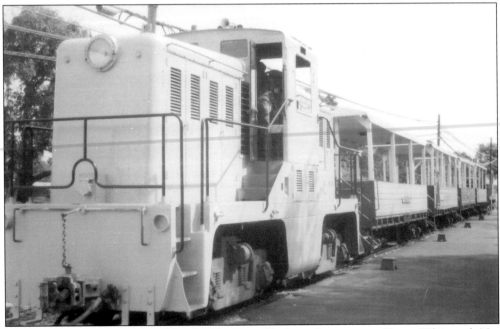

The third locomotive received by the Hawaiian Railway Society was 65-ton Whitcomb No. 65-00174. She had the distinction of pulling the last ammunition train in 1968 and, following an extensive restoration between 2011 and 2013, retraced at least a part of that route from Ewa to Kahe Point. (HRS.)

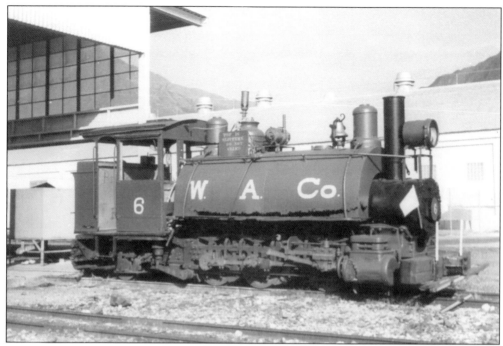

Pictured here is the locomotive that started the Hawaiian Railway Society (HRS), Waialua Agricultural Company No. 6, shortly after its arrival at Lualualei. No. 6 is one of only two locomotives known to have been built in Hawaii. Returned to operation in November 1972 after almost two years of work by the members and volunteers of HRS, No. 6 is currently awaiting a new boiler. (John Knaus, HRS.)

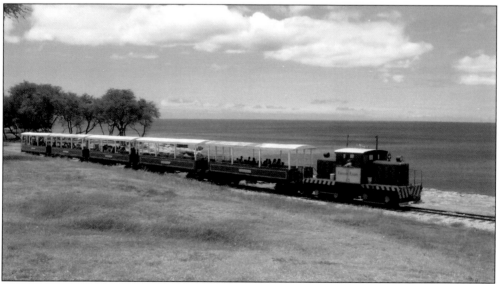

Pulled by Hawaiian Railroad Society locomotive No. 423, visitors in converted US Army flatcars enjoy the view of the Pacific Ocean from the mainline along the leeward coast of Oahu. (HRS.)

ABOUT THE
ORGANIZATION

The Hawaiian Railway Society was formed in August 1970 as a local chapter of the National Railroad Historical Society when the society acquired its first piece of equipment, Waialua Agricultural Company's Baldwin locomotive 0-6-2T No. 6. The Navy allowed the society to move the locomotive to the Naval Ammunition Depot, Lualualei, since it had the only locomotive-repair facility left on Oahu. The organization continued to acquire equipment from various public and private sources. The US Army donated a 25-ton General Electric Diesel and a number of ex-Army flatcars, and Bishop Museum transferred custody of Oahu Railway and Land Company locomotives 6 and 12 along with two passenger cars, a boxcar, and flatcar to the society. The rails were removed at Lualualei in 1978, and the society moved to its present location in Ewa adjacent to the only remaining portion of old Oahu Railway and Land Company track. The society continued to grow and acquire equipment over the years, albeit at a much slower pace. The society has restored and uses seven of the approximately twelve miles of existing right-of-way and offers regularly scheduled charter rides. The most recent acquisition of the society is OR&L Locomotive No. 85, a 1910-built ALCO (American Locomotive Company) 4-6-0 and the only remaining OR&L road locomotive in existence. Hawaii has a rich history of railroading. Seven public common carrier railroads ran on four of the islands, and at one time or another, 47 sugar plantations had private railway systems, each with between one and nine locomotives. The Hawaiian Railway Society is dedicated to preserving and presenting this history. For further information, including information about rides, please visit www.hawaiianrailway.com.

Discover Thousands of Local History Books
Featuring Millions of Vintage Images

Arcadia Publishing, the leading local history publisher in the United States, is committed to making history accessible and meaningful through publishing books that celebrate and preserve the heritage of America's people and places.

Find more books like this at
www.arcadiapublishing.com

Search for your hometown history, your old stomping grounds, and even your favorite sports team.

Consistent with our mission to preserve history on a local level, this book was printed in South Carolina on American-made paper and manufactured entirely in the United States. Products carrying the accredited Forest Stewardship Council (FSC) label are printed on 100 percent FSC-certified paper.

MADE IN THE USA